THE CHALLENGE TO REFORM ARTS EDUCATION:

What Role Can Research Play?

Edited by David B. Pankratz
and Kevin V. Mulcahy

ACA BOOKS
American Council for the Arts
New York, New York

ACA Arts Research Seminar Series Coordinator: Sarah Foote

©1989 American Council for the Arts

No part of this publication may be reproduced by any means without the written permission of the publisher. For more information, contact the American Council for the Arts, 1285 Avenue of the Americas, 3rd Floor, New York, NY 10019.

Edited by David Pankratz and Bruce Peyton
Jacket design by Joel Weltman, Duffy & Weltman

Director of Publishing: Robert Porter
Assistant Director of Publishing: Sally Ahearn

Library of Congress Cataloging in Publication Data:

The Challenge to Reform Arts Education/edited by David B. Pankratz and Kevin V. Mulcahy.
(ACA arts research seminar series; 4)
1. Arts — Study and teaching — United States. 2. Arts — Research — United States.
I. Pankratz, David B. II. Mulcahy, Kevin V. III. Series.
NX303.C47 1988 700'.7' 073 88-34274
ISBN 0-915400-73-1 (pbk)

*The ACA Arts Research Seminar Program
was made possible by a generous grant
from the Reed Foundation,
the John Ben Snow Memorial Trust and
the New York Community Trust*

CONTENTS

Appendices

ABOUT THE EDITORS

David B. Pankratz is an arts education/arts management consultant and professorial Lecturer in Arts Management at the American University, Washington, D.C. Formerly the director of program development at Urban Gateways: the Center for Arts in Education, Chicago, he writes frequently on issues in arts education and arts policy. He contributed an article on adult art education to the ACA Arts Research Seminar publication *Arts Education Beyond the Classroom* and recently coordinated the 14th Annual Conference on Social Theory, Politics, and the Arts at the American University.

Kevin V. Mulcahy is an associate professor of political science at Louisiana State University. A prolific writer, he is coauthor of *Public Policy and the Arts* and the forthcoming *America's Commitment to the Culture,* and contributed an article on cultural oversight to *Congress and the Arts: A Precarious Alliance?,* an ACA Arts Research Seminar publication. From 1980 to 1983 he was arts adviser to the Speaker of the Louisiana House of Representatives and has served on several advisory panels for the Louisiana Arts Council, including its Arts in Education Panel.

ACKNOWLEDGMENTS

The current move to reform arts education has attracted a great deal of attention. This is due, in part, to the urgent need to reform education generally in this country. It is also due to the realization by arts professionals that sound education in the arts is necessary in order to build and sustain a culturally literate society. Improved arts education depends upon developing a solid base of knowledge with which to plan and evaluate.

This fourth monograph in ACA's Arts Research Seminar Series seeks to examine the research that is now under way in arts education and to outline the research that still needs to be done. The book emanates from presentations delivered at a seminar entitled "After Interlochen: Research for a New Era in Arts Education," held 12 February 1988 at the University of the Arts in Philadelphia.

It is our great fortune that David B. Pankratz and Kevin V. Mulcahy were the editors of this volume. The high quality of this monograph is a testament of the thorough effort and dedication demonstrated by these two in both writing and editing this monograph and in planning and organizing the seminar.

We would like to extend our deepest gratitude to the authors who have shared their thoughts on complex and critical issues with unusual intelligence and clarity: Margaret K. DiBlasio, Samuel Hope, Jerrold Ross, Brent Wilson and Theodore Zernich.

We would like to thank John McLaughlin for his preface and for his briefing about results from the Interlochen Symposium at the seminar. We would also like to thank three of our ACA board members: John Straus and Fred Lazarus IV, for their skillful moderation of the morning and afternoon sessions of the seminar; and Sondra Myers, for her special assistance in helping to organize the seminar.

Finally, we are deeply indebted to the Reed Foundation, the New York Community Trust, and the John Ben Snow Memorial Trust, whose financial support have made this monograph possible.

SARAH FOOTE
Coordinator
Arts Research Seminars

BEYOND INTERLOCHEN: Coalitions, Research and Policy in Arts Education

by John McLaughlin

Perhaps at no other time has arts education had as much visibility as in the late 1980s. This attention, from both the arts and education communities, demands serious response from those who are evolving policy at the national, state, and local levels. Informed policy decisions must be based on rigorous research, for only research-based policy can assure a significant and permanent place for the arts in the school curriculum. That is what this monograph is about — the challenges faced by this diverse field as it undertakes the much-needed research that will serve as a basis for the arts education policy of the 1990s and beyond.

A major collaborative effort was begun in Philadelphia in March of 1986, when the American Council for the Arts (ACA) and the Music Educators National Conference (MENC) assembled thirty-one leaders from arts education associations, arts service organizations and arts advocacy groups to discuss common interests in arts education and what together they could do to promote the serious study of the arts in American schools. This first meeting led to the drafting of "The Philadelphia Resolution," which put forth some basic principles agreed upon by the entire group (see Appendix B). The document stated: ". . . we urge inclusion of support for rigorous, comprehensive arts education in the arts development efforts of each community. . . . we pursue development of local, state and national policies that result in more effective support for arts education and the professional teachers and artists that provide it."

After that initial meeting, these thirty-one leaders, known as the Ad Hoc National Arts Education Working Group, continued to meet in pursuit of the goals quoted above. During the next year, they drafted and presented to

John McLaughlin is the director of arts education at the American Council for the Arts.

their individual boards for approval a more sophisticated document outlining eleven principles for the improvement of arts education. This document, "Concepts for Strengthening Arts Education in Schools," calls for establishing the arts as "an equal partner in the educational enterprise" (see Appendix B) and, in order to achieve this curricular parity, asks that "the arts should be taught as disciplines to all students. This requires student involvement in creating, studying, and experiencing the arts." Another concept set forth in this document deals specifically with the topic of this ACARAC seminar:

> Basic research, model projects, and advocacy efforts are critical to establishing a consistent and compelling case for increasing the economic base of support for arts education in schools and in the community at large. . . . We must build a powerful community constituency at local, state and national levels among arts and art education organizations to initiate a step-by-step process for change.

In the spring of 1988 the group formalized its structure into the National Coalition for Education in the Arts (NCEA). The mission/principles statement developed by NCEA is based on the preamble of "Concepts for Strengthening Arts Education in Schools" and reads in part: "To increase the level of artistic literacy in the nation as a whole, the arts must be taught with the same rigor, passion and commitment with which they are created and presented to the public."

The mission of NCEA will be "to develop and monitor policy affecting education in the arts." To carry out that mission, NCEA will function in the areas of policy, advocacy and information dissemination.

During the three-year history of this coalition, members were also involved in the planning and execution of a major national invitational symposium, "Toward a New Era in Arts Education," held in November of 1987 at the Interlochen Arts Center in Michigan. Coconvened by ACA and MENC, the symposium brought together a wide universe of individuals and organizations involved with teaching the arts to students. The 150 participants represented arts education associations, arts service organizations, arts advocacy groups, education associations, state and local arts councils, foundations and corporations, school district administrators and teachers, artists and leading writers and researchers in the arts education field. During a three-day period, the group heard and discussed six papers addressing the following topics: arts curricula; developing professionals for arts education; long-range planning; partnerships with organizations, agencies and institutions; partnerships with teachers, artists and scholars; and ad-

vocacy and action strategies for strengthening arts education.

At the end of the three days, the symposium delegates produced thirty-two specific recommendations for improving arts education in local communities across the country. These recommendations were then consolidated into "The Interlochen Proposal," which states that to achieve the goals of improved arts education, "arts educators must collaborate with a broad range of colleagues in the arts, humanities and sciences to develop a school agenda that improves the total life of the school and allows each child to reach his or her full potential" (see Appendix A).

Specifically, the proposal urges: the development of better informational resources in the arts education field; strategies for evaluation that address the nature of the individual art forms and their respective instructional components; improvement of teacher training in the arts; and historical analysis of collaborative efforts in the arts. The recommendations, along with background material and the six papers, were published by ACA in the fall of 1988 as *Toward a New Era in Arts Education: The Interlochen Syposium.*The symposium, the proposal and the book all point to the need for improved research and information dissemination in the arts education field. They also demonstrate a rare and much-needed spirit of unity among those involved in arts education.

Currently, many researchers, organizations, collaborative ventures and writers speak in similar terms about improving arts education. This common language is evident in the National Endowment for the Arts' document *Toward Civilization* and is reflected in its new Arts in Basic Education Grants to the states and its joint support, with the U.S. Department of Education, of the National Arts Education Research Center at New York University and the University of Illinois at Urbana-Champaign. Improving visual art education and providing substantive research in that field has been the mission of the Getty Center for Education in the Arts from the Center's beginning. John Goodlad, Ernest Boyer and other individual educational researchers have also promulgated the message of the arts in the overall school reform movement. Finally, according to the Council of Chief State School Officers, an increasing number of states are considering the arts when they examine graduation requirements and new methods of teacher preparation in the process of formulating their education reform agendas.

This, therefore, may be the optimal moment for arts education. Within the next two to three years, each school system throughout the country should put into place an arts education policy that will assure a place for serious arts instruction within the curricular framework. These policies

must be informed by research. Consequently, any new research undertaken, along with critical past research, must be more widely disseminated to those in policy-making positions, especially administrators and school boards. Data collection and evaluation mechanisms need to be sharpened, and other significant areas of research that relate to arts education should be examined to determine how they can contribute to the knowledge base for the field.

The papers in this volume begin to address some of the complexities of arts education research. They examine various needs and cull possible solutions from the evolving body of research. This evolution must continue, and research findings must be disseminated as broadly as possible, so that policy makers at the national, state and local levels will have access to the best data, the best theory and the best research on past and present practice. Without informed policy, nothing of lasting significance will have been gained, and, when it is over, the high visibility currently being enjoyed by the arts education field will have been wasted.

ARTS EDUCATION RESEARCH:
Issues, Constraints, and Opportunities

by David B. Pankratz

This introductory essay will attempt to address three questions implied by the title of this volume: 1) is reform of arts education needed? 2) why is change in arts education so challenging? and 3) what role can research play in arts education reform?

Each of the following papers, by Brent Wilson, Margaret DiBlasio, Jerrold Ross, Theodore Zernich and Samuel Hope, addresses one or more of these issues. I will not recapitulate their views here but, rather, will attempt to provide a context for understanding them. This essay draws on two sources: the rich and varied literature in arts education, a good deal of which is footnoted, and the views of the many participants in the American Council for the Arts Research Advisory Council (ACARAC) Seminar held in Philadelphia in February 1988.

REFORM IN ARTS EDUCATION: IS IT NEEDED?

In every decade, it seems, American education inspires calls for fundamental reform of the schools. The 1980s are no exception. Countless research analyses, panel reports and personal expressions of opinion have indicted American schooling on counts such as curricular incoherence, low expectations of students, lack of teacher and administrator professionalism and general mediocrity. "Excellence," "substance" and "rigor" have been the watchwords of the education reform movement in the eighties.

Still, the "excellence" movement has not been characterized by a singular view of the state of American schooling and the changes that are needed. The diversity of views is illustrated, significantly, by the fact that some reports value arts education, while others do not. Views range from concepts of the arts as nonacademic, extracurricular activities that are worthwhile only for certain students,[1] to the arts as essential elements in the education of all students.[2] But even the most enthusiastic endorsements

have not impressed those who contend that most educational reform reports "stress only broad and general objectives which provide little specific or practical guidance"[3] to policy makers and practitioners in arts education.

This assessment highlights two important questions: how have arts educators viewed the educational excellence movement, and how has the reform movement shaped agendas for arts education reform? The program of the Getty Center for Education in the Arts can be analyzed in light of these questions. The Getty Center, as is well known, advocates discipline-based art education (DBAE), which prescribes curricular attention to four basic arts disciplines: art production, history, criticism and aesthetics.[4] On the one hand, the concept of DBAE has deep historical roots. Its theoretical[5] and curricular antecedents[6] date back to the curricular reform movements of the 1960s,[7] and the present movement has been bolstered by philosophical, empirical, curricular and historical research.[8] On the other hand, findings from an early 1980s study of school art programs[9] led the Getty Center to conclude "that if art education is to ever become a meaningful part of the curriculum, its content must be broadened and its requirements made more rigorous."[10] Significantly, the Getty Center argues that, as DBAE relates to the questions cited above, its emphasis on rigor places DBAE squarely within the educational reform movement. Another example of this relationship is the National Art Education Association's publication of *Excellence in Art Education*[11] as a substantive response to the excellence-in-education movement which elaborated the idea of an excellence curriculum for art education. A final example is a Chief State School Officers study of state arts education policies which concludes that the arts can make a significant contribution to the total effort of general education reform.[12]

To suggest, however, that calls for reform in arts education have been shaped solely by the excellence-in-education movement would be mistaken. Many cases for arts education reform echo broad-ranging discussions of the lack of cultural literacy and a common culture in American society. Volumes such as those by Bloom,[13] Hirsch[14] and Cheney[15] variously contend that superficial views of cultural diversity as well as the predominance of popular culture have contributed to isolation from the cultural heritage of Western civilization. Each argues for greater educational stress on the common values and traditions characteristic of American high culture. Additional impetus to arts education reform has been provided by recent research studies on public participation in the arts. Previous research focused on socio-demographic correlates of attendance at arts events[16] or polls of Americans' opinions about the arts.[17] But the National Endowment

for the Arts' *Survey of Public Participation in the Arts*[18] measured rates and types of adult arts participation in behavioral terms. A primary finding was that "61 percent of Americans did not attend even once — any live performance of jazz or classical music, theater, opera or musical theater, or ballet, nor did they visit an art gallery or museum."[19] A follow-up NEA study, which looked at a variety of socialization variables, concluded that people with more and varied socialization experiences also report higher rates of arts participation as adults.[20]

Toward Civilization, the recent NEA report on arts education, analyzes basic elements of the arts education world — curricula, teachers of the arts, testing, leadership, etc., and concludes that "basic arts education does not exist in the United States today."[21] But, ultimately, assessments of these elements reflect the sources of arguments for arts education reform — the excellence-in-education movement, cultural literacy and common culture, and studies of public participation in the arts. These sources of arguments are also reflected in a number of ways in The Interlochen Proposal, which concludes that American schools, K-12, should provide arts education for all students every day and should maintain an in-school, sequential arts education program.[22]

To argue that reform of arts education is needed by pointing out gaps between current realities and ideal conditions does have its value. But it does not address the issue of the purposes that arts education should serve. Articulation of these purposes is best found in the conceptual research of arts educators, who justify arts education based on views of the nature of the arts and their roles in human experience, both individual and social. Some justifications are rooted in aesthetic theories of art which hold that skillful interaction with the arts offers a distinctive, self-sufficient quality of experience, usually termed aesthetic experience.[23] Other justifications stress cognitive or knowledge claims for the arts. Ranging from Susanne Langer's theory that the arts are symbolic images which afford knowledge of untranslatable forms of the range of human feeling,[24] to Nelson Goodman's theory that aesthetic experience is characterized by symbolic functioning,[25] these views support the argument that the arts are acts of intelligence which, if underdeveloped, constitute a form of intellectual deprivation.[26] Additional justifications include claims that the rich images of the fine arts function as exemplars of human values and that arts education is needed to counteract powerful, stereotypical images of the popular arts as part of value education[27] and the process of cultural formation.[28]

These basic justifications, whether wholly persuasive or not, do illustrate that for some time arts education researchers have offered detailed ration-

ales for why arts education is needed. When combined with current calls for reform in arts education, these arguments suggest that some level of consensus has emerged that changes in K-12 arts education are essential. But questions about what changes are required, and how change can be achieved, remain unanswered. This point leads to the next question.

WHY IS CHANGE IN ARTS EDUCATION SO CHALLENGING?

Any attempt to address this question involves consideration of a staggering number of challenges both within and outside the arts education enterprise. A select few will be discussed here, primarily to provide additional context for answering the question of what role research can play in arts education reform.

1. To many, the term *arts education* is a misnomer and at best simply a useful convenience for referring, collectively, to education in the individual arts of music, art, theater, dance, creative writing and media arts.[29] Some might say that avoidance of this term is a function of mutual suspicion fostered by political struggles to secure precious time within the school day and curriculum. In any case, each of these disciplines does have its own history, theoretical bases, content, traditions of practice and, significantly, status within the schools. Thus, while it may be true that reform in arts education is needed, it is more accurate to say that each arts discipline has its own challenges and that theater, dance and media arts face particularly difficult challenges.[30]

2. Charles Fowler rightly contends that there are a number of fundamental dilemmas, many of which have pervaded arts education for years, which stand at the center of any possible change in arts education today.[31] A few notable examples are: What roles should classroom teachers, arts specialists, and visiting artists play in the delivery of arts instruction, and what training and certification/accountability standards are appropriate for each? Should arts education stress art production and performance or give equal emphasis to learning in criticism, history and aesthetics? If so, to what degree and at what stages of development? In a pluralistic, multi-cultural society, what cultural forms and arts styles should be taught? What role should student achievement testing and program evaluation play in arts education? What place can community arts resources have in arts education? How will socio-demographic trends such as the aging of America, increased cultural diversity, life-style changes, and changes in electronic media affect policy development in arts education?

3. A key source of potential leadership for arts education is the education sector at the local, state and national levels. While notable examples of leadership at each level can be cited,[32] these tend to prove that the education sector's commitment to arts education is inconsistent at best. As a result of pressure on educational leaders to stress "basic skills" and remedial programs in these areas, support for arts education has dwindled at the local school level, at least according to the CSSO study cited above. The study also noted that "other traditionally elective subjects, such as vocational education and foreign languages, are often viewed by parents . . . as more practical for college or career preparation."[33] This latter point echoes the concerns of many about the American value system, i.e., that the majority of Americans view education as a means to secure competitive advantages in a technological, materialistic society. The arts, then, are seen as ornamental background to other more important activities.[34] While selected opinion polls reveal that clear majorities of adult Americans "believe that the arts should be taught as regular, full-credit courses,"[35] such polls usually ask questions in the abstract without due consideration for scenarios requiring difficult choices among curricular priorities.

4. The arts sector potentially can be an important advocate for K-12 arts education reform. But in the past, public arts agencies and community arts resources have often been charged by professional arts educators with attempting to "de-school" arts education and with displaying insensitivity to the long-term effects of their arts education programs on the continuation and growth of school-based K-12 arts curricula.[36] Some have speculated that since the wealthy, well-educated patrons of arts organizations developed their affiliation with the arts through familial, non-school socialization experiences, their advocacy of arts education shows little regard for the role that school-based programs can play in delivering systematic instruction to all students, whatever their social backgrounds.[37] Despite past struggles, the relationship between the arts and arts education communities seems to be improving. For example, in 1986, the American Council for the Arts and the Music Educators National Conference convened a group of more than thirty leaders from arts education associations, arts advocacy groups and arts service organizations. Named the Ad Hoc National Arts Education Working Group, this body has produced two documents (see Appendix B) which express common values and conceptual guidelines for improvement in arts education. Additionally, a 1987 publication by the National Assembly of State Arts Agencies was designed to stimulate ideas about how public arts agencies, community arts resources, arts educators and education agencies can fashion more effective collaborations in support of basic, sequential K-12 arts education.[38]

5. A final factor affecting the possibility of arts education reform is the complex array of individuals, institutions and organizations that can facilitate or inhibit change in arts education. These many elements are too numerous to mention here, but *Toward Civilization* discusses them at some length. This complexity obviously presents challenges for arts education reform and highlights the need for broad-based policy development which takes holistic views of the roles that the many leadership sectors shaping arts education can exercise. Although there is no shortage of cooperative arts education program models,[39] descriptive accounts of these models often focus largely on a few key program elements as they have been developed and implemented in local situations. There are very few models of policy development in arts education, either those which describe processes in local situations or models which attempt to generate basic principles by analyzing, comparing and contrasting policy development processes in diverse situations.[40] Further, the relationship between policy development and advocacy in arts education is close. Arts education advocacy deals with strategies to implement desired policy changes.[41] But without sound policy development at its base, arts education advocacy can easily lead to action for action's sake, whatever its good intentions, with an array of potentially damaging consequences.

WHAT ROLE CAN RESEARCH PLAY?

It should be clear from the above discussion that a diverse body of research in education, arts education and the arts has contributed in substantial ways to calls for arts education reform by defining the nature of reform that is needed and addressing impediments to change. But a key point must be made: while some research has been self-consciously related or adapted to reform agendas, the vast majority of research in arts education has been pursued out of a desire to expand the knowledge base of arts education practice and policy, and not out of a desire to contribute to a particular agenda. To expect arts education research solely to serve current or popular ideas of reform is to distort the purpose of research in the field. Indeed, researchers have an obligation to analyze, interpret and critique basic tenets of reform agendas in arts education. This work has already begun on a number of fronts,[42] but for arts education research to take on a variety of roles, there are many issues which must be addressed and, if possible, resolved. These issues include concepts which shape research priorities, methodological bases, research questions, the gap between research, practice, and policy, and barriers to the expansion and increased effectiveness of arts education research.

Conceptual Influences in Arts Education

Value-laden concepts of culture, the arts and education explicitly or implicitly shape both the formation of goals in arts education and the selection or non-selection of research questions in the field. Historical concepts of culture vary considerably and can be fairly categorized into three types.[43] Liberal humanists view culture as an individual, refined sensibility developed through immersion in the "best that has been thought and said" in Western civilization. Culture becomes a moral and humanizing antidote to mass production culture.[44] Liberal pluralists, rooted in the relativistic assumptions of functionalist social science, view culture as the whole way of life of a people. The arts are cultural products which reflect a culture's belief system through symbolic expression and thus help to perpetuate a culture's identity and conception of reality.[45] Neo-Marxists contend that the arts of high culture in their production and dissemination function to reproduce inequitable power relations and the status quo, and thus deny opportunities for dominated cultural groups to develop alternative conceptions of artistic value.[46] These views of culture find parallels in broad-based concepts of cultural policy, ranging from the democratization of culture (promoting wide access to art of high aesthetic value)[47] to cultural democracy (fostering the capacities of cultural groups to create and disseminate their own cultural products).[48]

As with concepts of culture, concepts of education most often implicitly shape emphases in arts education research. Historically, of course, aims of education have been conceived of in a multitude of ways: to initiate the young into forms of knowledge in the culture; to prepare students for informed participation in the democratic process; to sort and differentially train youth for productive roles in the world of work; and so on. Some attempts have been made to place explicit goals for arts education within a theory of general K-12 education, notably Harry Broudy's view of the role of aesthetic exemplars in value education,[49] but such attempts are rare despite urgings by some arts education researchers.[50]

Views of arts education have, however, explicitly shaped research priorities in the various arts disciplines for some time. For example, visual arts educators traditionally have stressed the creative processes of children and their products, child art. Thus, studies of the meaning of children's drawings and of stages of artistic development appear in the art education research literature more frequently than studies of perception and critical judgment of works of art, and far more often than research on the effects of, for example, instructional strategies in art education.[51] Similarly, the histori-

cal paradigm of creative dramatics, stressing development through dramatic activities, has shaped research emphases on the personality, attitudinal and learning consequences of dramatic activities.[52]

In addition to these conceptual influences, choices of research methodologies have been primary determinants of research priorities in arts education. This relationship will be examined in the next section.

Methodological Issues in Arts Education Research

Discussion of research methodologies in arts education must consider the historical relationship of the arts and science. Harlan Hoffa has said that research "is not an idea that has grown naturally out of artistic traditions. The arts and the sciences . . . have evolved idiosyncratic modes of inquiry, each of which is unique to its needs and purposes . . . and deviations from those established patterns, though not uncommon, appear as aberrations."[53] Others, however, have tried to bridge either-or attitudes. For example, Richard Courtney argues that "the artist and the scientist have their own ways to discover knowledge and meaning. Neither is better or worse than the other. Rather, they complement each other."[54]

The generation of scientific knowledge in arts education is extremely complex. Researchers confront a basic paradox — "that every human being is, in certain respects, like all other human beings, like some other human beings, [and] like no other human beings."[55] Additionally, artistic experience — both creativity and perception — is richly subjective in nature and hence not easily accessible to objective observation. Arts education research cannot hope to achieve the validity and reliability of research in the physical sciences, for example. Instead, it tends to identify and clarify tendencies, set parameters and options for decision-making, and establish probabilistic relationships between variables of human behavior in the arts.

Methodological discussions often proceed at this point to descriptions of arts education research methods — including historical, philosophical, experimental and descriptive approaches — and distinctions between basic and applied research. But these issues are well presented in other essays in this volume. Instead, I will discuss a fundamental issue which underlies consideration of research methods: the distinction between quantitative and qualitative research. Recent major research studies in arts education have assumed the complementary value of qualitative and quantitative methods,[56] but some educational researchers continue to wonder what the relationship between these different kinds of methods should be.[57]

The respective methodologies of quantitative and qualitative research differ on several basic grounds:

Assumptions. Quantitative research assumes that there are social facts with an objective reality apart from the beliefs of individuals. In contrast, qualitative research assumes that reality is socially constructed through individual or collective definitions of situations.

Purposes. Quantitative research aims to discover true and verifiable knowledge by explaining the causes of social facts or changes in social facts, primarily through objective measurement tools. Qualitative research is concerned with the understanding and illumination of the perspectives of participants in social situations, primarily through researchers' disciplined participation in those situations.

Approaches. Quantitative researchers focus on manifest behavior, employ experimental or correlational designs to reduce error and researcher bias, and report results in formal statements which express quantitative relationships in propositional form. Qualitative researchers focus on the meanings that situations have for individuals and others, employ descriptive and ethnographic methods which seek to reveal the rich complexity of those situations, and reveal meanings in unique, idiosyncratic research formats whose validity is judged not by statistical significance but by persuasiveness of personal vision, a criterion which allows researchers a greater degree of license to make results vivid by selective emphasis on significant details.

Educational researchers such as Smith and Heshusius argue that attempts at an easy rapprochement between quantitative and qualitative research reflects "an uncritical dependence on the idea that inquiry is a matter of what works"[58] without due consideration to the basic, conflicting philosophical foundations underlying the different methods. Smith and Heshusius further state that these differences have important practical consequences, asking, "On what basis can researchers justify their work to the public, to educators, and, for that matter, to themselves? Do researchers, as is commonly held, deserve a hearing because [quantitative] method places them above the subjectivity common to everyday discourse and thus allows them to speak of things as they really are?"[59] Or, as qualitative inquiry holds, is research "nothing more or less than another voice in the conversation — one that stands alongside those of parents, teachers, and others . . . These differences easily spill over into the issue of how researchers resolve disagreements among themselves over the results of inquiry. If quantitative inquirers, they hold out the possibility that a return to the facts of the case will sort out the problem . . . Qualitative inquiry, on the other hand, has no

independent or 'brute' facts to appeal to If people agree, it is because they share similar values, interests, and purposes—not because there are any [facts] that compel agreement."[60]

Arts education researchers have yet to enter full-blown into the quantitative-qualitative debate, but the historical practice of researchers in the different arts disciplines is instructive. Music education researchers, far more than those in the other disciplines, utilize quantitative methods in experimental and quasi-experimental research designs,[61] "because when applied judiciously, they are known for their validity and reliability."[62] Only recently have music researchers begun to explore qualitative methods such as ethnographic research.[63] On the other hand, visual art education researchers have endorsed qualitative methods for some time,[64] producing studies of school art education programs utilizing methods such as participant observation, case study, field study, connoisseurship and ethnology.[65] Significantly, visual art educators have also begun to subject the quantitative-qualitative issue to socio-political analysis. For example, Eisner argues that quantitative methods still maintain hegemony among educational researchers and that "when such an orientation to research and knowledge becomes salient in our professional socialization, the methods . . . become political in character"[66] and thus confirm legitimacy upon those who uphold their use. In contrast, John J. Jagodinski suggests that the increasing popularity of qualitative methods reflects an underlying value orientation toward participatory democracy, pluralism and diverse aesthetic standards. But he also contends that the particularism of qualitative methods often fails to reveal how larger socio-economic and political structures shape the actions and choices of research subjects under study.[67] Also, some have argued that researchers should develop basic descriptive data as a necessary prelude to complex, quantitative research designs, stating that "such a data base is embarrassingly absent from too many areas of concern in [arts education]. It appears that we have attempted to become too sophisticated too quickly."[68]

Finally, many worry that arts education researchers, in their attempts to be "scientific" or to gain legitimacy within university settings, have too often allowed fidelity to accepted research methodologies to "force them into research models that elude the real issues of the field."[69] Indeed, a similar criticism has also been made against those utilizing new methods from social sciences such as sociology and anthropology.[70] The frequently recommended remedy is that arts education researchers must first define key issues requiring study and then develop the methods best suited to researching those issues. This point leads to another question: what are the key issues in arts education that should be researched?

Arts Education Issues Requiring Research

This section is designed to summarize at least some of the major issues that arts education researchers have identified as being under-researched in the field.

One aspect of contemporary philosophy aims to probe, analyze and clarify the concepts that we employ in our everyday thinking and talking.[71] Arts educators can draw on the work of philosophers in clarifying concepts of art, culture and education to serve as bases for discourse about arts education practice and policy. But arts educators must analyze the unique "conceptual baggage" of their field by themselves.[72] As an example of this approach, Margaret DiBlasio reveals that the omnipresent concept of "child art" is at best vague and ambiguous, and "presents the likelihood . . . of disrupting the continuity and consistency of a sequenced art curriculum."[73] Other arts disciplines doubtless have concepts needing clarification too.

An ongoing issue in arts education is the relationship between human development research and research on instruction and learning in the arts.[74] The most influential basic research on developmental aspects of the arts has been conducted by Harvard Project Zero over the last twenty-five years. Project Zero researchers share a number of fundamental convictions: "a belief that the arts, usually celebrated as the dominion of the emotions, are profoundly cognitive activities; a belief that human intelligence is symbolically mediated through and through and must be understood from the perspective of symbolic development; a belief that creative and critical thinking in the arts and sciences have far more in common than is often thought; a concern to study and understand the psychological processes and resources underlying some of the peak achievements of humankind."[75]

Project Zero is committed to theoretical and empirical research to clarify issues and propose hypotheses for testing development in the arts. Some researchers have sought to go beyond aims to observe, describe and characterize the regular, universal changes that occur in the natural processes of human growth and development in order additionally to study how non-universal elements such as cultural influences, direct instruction, exposure and conscious choice facilitate individuals' mastery of knowledge or artistic development either in stages or in idiosyncratic ways.[76] Significantly, other researchers, while praising the progress of Project Zero's work on arts development, conclude that "work has been slower in learning how to train these abilities and in understanding how education affects development."[77] Howard Gardner acknowledges that "developmental factors may

set a kind of upper bound on what can be mastered at any particular time, but certainly the crucial factor [in learning] is the quality of education."[78] As a result, Project Zero has stepped up its study of the relationship between developmental factors and educational intervention by undertaking two school-based collaborative research projects: Project Spectrum and Arts Propel.[79] It has been argued that developmental research has inappropriately dominated arts education, to the neglect of instructional research. Whether this is true or not, more related developmental/instructional research is needed.

Also underdeveloped is research on arts education curricula, in part a reflection of historical attitudes holding that arts teachers should be relatively free to invent curricular content, set objectives and design activities for classroom use.[80] Arts educators, however, have developed a broad body of theory on curriculum development and curriculum models in arts education.[81] Many theoretical issues remain to be resolved, such as the ideal balance of creation/performance, history and critical judgment skills, the relative curricular emphasis on Western, non-Western, classic and contemporary arts, and whether the arts should be taught as separate subjects, as part of related arts programs or by integrating them into other academic subjects. Indeed, Brent Wilson has called for a national debate on arts curricula.[82] But despite these vexing issues, development of curriculum materials has proceeded in each of these arts disciplines. These curriculum materials primarily have been developed in what Eisner terms the "external mode,"[83] in which curricula are developed in locations outside of the context in which they are used by curriculum specialists hired by commercial publishers, state education agencies, voluntary committees or government-supported agencies.[84] Analysis of the curricular goals, objectives, sequence and content of these curriculum materials is quite rare and needed.[85] Even greater is the need for research that tests the effectiveness of available arts curricula in terms of teacher utilization and student learning, for studies of how these curricula are adapted to local conditions by school systems and administrators, and for research on the "operational curriculum"[86] (what individual teachers actually do with the materials they have to work with, and how their choices shape the specific kinds of classroom experiences students have).

A corollary need is research that investigates issues of teacher education and in-service training in the arts. The recent Holmes Group[87] and Carnegie Forum[88] reports made wide-reaching recommendations on changes in teacher education, and arts educators have written responses to these ideas and formulated proposals that consider the unique requirements and conditions of teaching in the arts.[89] But research on the relationships between al-

ternative types of teacher preparation/in-service training and qualitative differences in the practices and skills of arts teachers is almost nonexistent, at least in published form.

Research is rare which looks at how the many elements cited above work together or in conflict in the formulation of policies or entire arts programs, especially at the state and local levels. There are a few examples, such as the Getty Center/Rand Corporation study of school districts that incorporate DBAE elements in their programs.[90] But more detailed and more numerous "systemic" studies are needed, especially those which would look at such additional factors as leadership, funding and strategies for change.

Finally, as Sam Hope suggests later in this volume, arts education as a field has yet to develop a capacity to conduct policy research. While policy research can be defined in various ways,[91] it generally focuses on contextual issues which facilitate or inhibit an enterprise as well as the relation of means to broadly defined ends. A wide range of contextual issues must be considered in long-range planning for arts education. They are demographic, economic, sociological, political, ideological and aesthetic in nature and affect many dimensions of arts education, education and the arts in overlapping ways. These factors, for the most part, are not within the power of arts education leaders to control directly. The challenge becomes to avoid passive reactiveness to these trends and to assess their potential influence in order to develop strategic policy options which are within the decision-making control of leadership sectors in arts education.

Research, Policy, and Practice

The issue of the "gap" between research and practice has historically produced acrimonious charges and countercharges between producers of arts education research and some of its potential consumers, in particular, arts teachers at the elementary and secondary levels.[92] Many arts teachers (and some arts education researchers) believe that researchers address trivial questions, often remote from issues that teachers deal with, resulting in isolated bits of knowledge that rarely build upon each other.[93] Even research results with potential utility for teachers, it is argued, are obscured by unnecessary jargon, hidden by complicated forms of presenting research findings, and buried in professional journals that function as reputation building vehicles for university-based researchers.[94] (Reports are frequent of the lack of arts teachers among the readership of professional journals.[95])

Whether these charges are fair or not, arts education researchers have offered various explanations for the research-practice gap, explanations that are historical, cognitive, sociological and political in nature. Jack Taylor

points out that arts education research, given its relatively brief history, "has yet to establish the research tradition — and therefore the acceptance — that has already happened in other fields."[96] Laura Chapman suggests that arts teachers, often because of their professional training, view reason and feeling as opposed rather than complementary, and hence tend to value organized knowledge and research far less than the freedom "to follow . . . intuitions, try out new ideas, and learn by trial and error."[97] Joseph La-Chappelle seeks explanation of the "gap" in sociological theory which holds that conflict between university-based researchers and arts teachers is waged not over the content or uses of research but over who *controls* research and professional pre-service/in-service education.[98] As evidence of this social conflict, LaChappelle cites a 1970s conference on research and practice in arts education at which arts teachers "did not express a felt need for guidance from the research community, but were more interested in the idea of teachers conducting their own research."[99] Finally, Chapman argues that political pressures have distorted the purposes of research and exacerbated the research-practice conflict. Specifically, she charges that applications of business techniques, such as cost-benefit analysis, to educational research, has led to the wrong-headed view that research must "produce an immediate payoff in the achievement of youngsters or in the improvement of schools."[100]

Arts educators have also sought ways either to bridge the research-practice gap or, in some cases, to redefine the issue. For example, each of the professional arts education associations — the Music Educators National Conference (MENC), the National Art Education Association (NAEA), the Association for Theatre and Education, and the National Dance Association — in part through research committees, has taken steps to disseminate research to arts teachers. MENC's specialized *Journal of Research in Music Education* regularly presents a "Research Connection" column in the organization's general membership publication, *Music Educators Journal,* and *Update: The Applications of Research in Music Education* was begun in 1982 to respond to the "anti-research attitude among many music teachers."[101] Similarly, NAEA has initiated, as a membership benefit, "NAEA Advisory," an ongoing series of short publications tracing the implications of current research and ideas for educational practice. Finally, *Youth Theatre Journal,* which formerly published one special research issue per year, now incorporates research articles in all of its issues.

While these efforts have received praise, many arts educators have argued that a key element in bridging the gap lies with teacher preparation in the arts. As D. Jack Davis states, "the education of the practitioner should treat research as an integral part of the field and not as a phenomenon in

opposition to the very essence of the arts themselves."[102] John Grashel details several ways of promoting an understanding of research as a basis for future music teachers' professional practice: the use of research findings in teaching methods classes; the incorporation of pertinent research in methods textbooks; the "modeling" of research practices by music professors; student participation in studies of teaching situations; and education in a wide range of quantitative and qualitative research methods.[103] Harry S. Broudy predicts that without foundational studies in research, future teachers not only will have low regard for theory and research but, more significantly, "will wait patiently for consultants and publishers to provide a kit of tools and procedures that will tell them 'how to' manage the crises in the classroom."[104] But Davis concludes that "perhaps most importantly the practitioner must be educated to realize that the outcomes of research will not always be instantaneous."[105] This view is based on the idea that while research can influence arts teaching in many subtle and long-lasting ways, "it does not come with a built-in guarantee that it will be useful to inform practice . . . nor will it always be useful in solving every professional problem that we face."[106]

Unique institutional arrangements have begun to address the research-practice gap. The Getty Institute for Education in the Arts, for example, is designed to serve as a multi-year longitudinal study of visual arts education, from theoretical foundations to classroom applications, in a theory-practice "loop."[107] Also, the work of the National Arts Education Research Center at New York University, discussed by Jerrold Ross later in this volume, aims to develop selected teachers' research skills and pool their findings to validate principles of "exemplary" teaching practice in the arts. These institutional arrangements, in spirit, reflect educational researchers' increased focus on the realities of classroom life and the involvement of teachers in the design and conduct of research.[108]

Far less has been done by the field of arts education to address another key issue: the gap between research and policy-making in arts education, education and the arts. *Design for Arts in Education* magazine has worked virtually alone to increase the quality of debate about policy issues among these diverse sectors. Some in the field remain skeptical about whether policy makers are interested in arts education research. Theodore Zernich, at the ACARAC Seminar in Philadelphia, stated that policy makers are primarily interested in raw data and statistics and that, without these, arts education will be left off the agendas of educational policy makers. Others have argued that "decisionmakers are often impatient with calls for explicit, detailed policies based on thorough research. A typical approach views policymaking as a pragmatic day-to-day response to problems and that

emerging concepts, when taken together, constitute a policy."[109] If the research-policy gap is to be bridged, efforts must be launched in two key areas: policy analysis must be developed as a methodology in arts education research, and strategies must be devised to broaden the "consumer base" for arts education research to include policy makers in the many leadership sectors of arts education, education and the arts.

Problems and Opportunities for Arts Education Researchers

If arts education research is to play a significant role in support of arts education reform, in challenging key premises of the current reform movement, or simply in creating more effective and useful research, its researchers must be helped to overcome the barriers that inhibit the creativity and productivity of even the most highly original minds. Difficult working conditions in the university settings where they work may include heavy teaching loads, expectations of artistic creativity, and too few research assistants; often, their research is valued less than that of other academic disciplines, applied research is discouraged,[110] and risk-taking is difficult.[111]

Lack of external resources complicates this picture. There is no single entity or agency which has as a primary mission the systematic, ongoing collection of basic, reliable information on arts education. Most sources of information are the result of special surveys or information sweeps by government agencies, professional associations, or private foundations.[112] But without regular, assured collection of these data on an ongoing basis, theory generation, secondary data analyses and integrative research reviews by arts education researchers will be limited.

Funding for arts education research, from government and private sources, has always been problematic. The Arts and Humanities Program of the U.S. Office of Education was influential in the 1960s, and elaborate, cross-disciplinary research priorities were set. But according to Stanley S. Madeja, "No support was provided over a long enough period to have any significant effects."[113] The NEA's Research Division, created in the mid-1970s, has sponsored only one study that dealt specifically with arts education, and that 1978 study focused primarily on the training of artists.[114] More recently, and more encouragingly, the National Arts Education Research Center, created in 1987 jointly by the U.S. Department of Education and the NEA and discussed in the following papers by Ross and Zernich, does represent a reassertion of a federal role in support of arts education research, at least for the next three years.

Private funding of arts education research has also been erratic. The continuous support that Project Zero has received for twenty-five years is an exception that proves the rule. Programs like the JDR 3rd Fund, which conducted case study research on arts-in-general-education programs in the 1970s, have come and gone.[115] And the Getty Center has taken great pains to inform the field that it does not have an unlimited source of funds.

Problems associated with external funding of arts education research extend beyond the limited amount of funds. Government agencies, in many instances, "contract out" research services to university-based or independent researchers. But critics of this widespread practice argue that since the information required to make "contracting out" decisions is costly, in terms of both time and money, government agencies often base their assessments of potential providers of research services on imperfect information and thus tend to rely on existing or advantageous social relationships.[116] Charles Fowler maintains that private funders can set either prescriptive or conscriptive policies for support of arts education research.[117] Prescriptive policies involve a new and compelling vision of arts education around which theory, research and practice can mobilize. But Fowler warns that "prescriptions tend to fade as they are partially achieved, as opposing or competitive forces erect successful blocks, or as better prescriptions are established."[118] Conscriptive policies reward imaginative ideas generated from the field, and operational control of theory, research and practice tends to remain in the hands of arts education researchers and practitioners. Ideally, arts education researchers should be in a position to analyze and evaluate the relative merits of these different funding policies. But such objectivity is often difficult in the face of legitimation and support from external funders.

These many barriers to the growth of arts education research make setting and implementing a future research agenda for the field an extremely difficult challenge. Elliot Eisner has argued that while a piecemeal approach to arts education research can produce research of value, the identification and pursuit of a research agenda is an essential means of stimulating research vitality and eventually improving educational practice.[119] There has been no shortage of research agendas in the field's past. Some of them, such as the agenda set at a CEMREL-sponsored meeting of arts education researchers and policy makers in 1976, have been quite detailed.[120] More recently, *Toward Civilization* offers a research agenda focused "on matters that can actually improve what is done in the classroom."[121] Also, at a 1987 Getty-sponsored seminar of scholars designed to explore philosophical/conceptual concerns underlying DBAE, the participants, in effect, formulated a full research agenda.[122]

Hermine Feinstein, one of the Getty seminar organizers, states that a key to successfully implementing a research agenda in the field is a "community of scholars," the development of which "demands inquiring minds, ego-strength, intellectual integrity, rigor, commitment, and a willingness to extend horizons."[123] But participants in the ACARAC Seminar suggested another condition for the development and implementation of any research agenda: a coherent policy for arts education research. Of course, this notion begs many questions. Who would be involved in setting such a policy? What would be the policy's short-term and long-term goals? What sort of institution(s) should oversee the policy's support and implementation? What criteria would be used to measure the policy's effectiveness?

Interestingly, the sciences have already begun to explore the need for policy formulation to support scientific research in the 1980s and beyond. Phillips and Shen argue that, in decades prior to the 1980s, "the consequence of all of the independent actions by the federal government and the universities was a de facto, healthy research system that met the needs of both."[124] But changed conditions in this relationship have spawned policy studies of the research systems of contemporary science.[125] These studies have focused on a number of factors making up the "ecology" of scientific research. *Institutional factors* include the presence or absence of barriers to research, the critical mass of cooperating colleagues and the institutional track record in producing quality research. *Entrepreneurial skills* constitute another set of factors, including the experience and skill of researchers in securing external funding, and their ability to plan, manage, evaluate and disseminate research. Finally, *external funding policies* encompass trends in government and private funding, the relative emphasis on basic or applied research, and the strengths, weaknesses and biases in funding-decision processes. Generally, these factors are in turn related to additional variables, such as the quality and quantity of the research conducted. Ideally, then, studies of research systems identify those factors that can be controlled or altered through changes in policy mechanisms to enhance the conditions which foster high-quality, effective research.

Some of the factors that inhibit research in arts education were cited earlier. However, this discussion was not informed by the type of policy studies underway in the scientific community; such studies would seem indispensable to the task of identifying the many elements that would make up a broad-based policy for arts education research. Guided by a carefully formulated policy, the great potential of arts education researchers to shape reform in arts education may be more fully realized.

NOTES

1. See, e.g., National Commission on Excellence in Education, *A Nation at Risk: The Imperative for Educational Reform* (Washington, D.C.: U. S. Department of Education, 1983); *Action for Excellence* (Denver: Education Commission of the States, 1985); and *Investing in Our Children: Business and the Public Schools* (New York: Committee for Economic Development, 1985).

2. See John I. Goodlad, *A Place Called School: Prospects for the Future* (New York: McGraw-Hill, 1984); Ernest L. Boyer, *High School: A Report on Secondary Education in America* (New York: Harper and Row, 1983); *Academic Preparation for College: What Students Need to Know and Be Able to Do* (New York: College Board Publications, 1983); Mortimer J. Adler, *The Paideia Proposal: An Educational Manifesto* (New York: Macmillan, 1982); and William J. Bennett, *First Lessons: A Report on Elementary Education in America* (Washington, D.C.: U. S. Government Printing Office, 1986).

3. Ralph A. Smith, *Excellence in Art Education: Ideas and Initiatives* (Reston, VA: National Art Education Association, 1986): 7.

4. Getty Center for Education in the Arts, *Beyond Creating: The Place for Art in America's Schools* (Los Angeles: Getty Center for Education in the Arts, 1985).

5. See, e.g. Manuel Barkan, "Is There a Discipline of Art Education?" *Studies in Art Education* 4, no. 2 (1963): 4-9; Harry S. Broudy, *Enlightened Cherishing: An Essay on Aesthetic Education* (Urbana: University of Illinois Press, 1972); Laura H. Chapman, *Approaches to Art in Education* (New York: Harcourt Brace Jovanovich, 1978); Elliot W. Eisner, *Educating Artistic Vision* (New York: Macmillan, 1972); Edmund Burke Feldman, *Art as Image and Idea* (Englewood Cliffs, N. J.: Prentice-Hall, 1967); and Ralph A. Smith, ed. *Aesthetics and Criticism in Art Education* (Chicago: Rand McNally, 1966).

6. See, e.g., M. Barkan, L. Chapman, and E. Kern, *Guidelines: Curriculum Development for Aesthetic Education* (St. Louis: CEMREL, 1970); E. Eisner, *Teaching Art to the Young: A Curriculum Development Project in Art Education* (Stanford, CA: Stanford University, 1969); F. Hine, G. Clark, D. W. Greer, R. Silverman, *The Aesthetic Eye* (Los Angeles, Office of the Los Angeles County Superintendent of Schools, 1976); G. Hubbard and M. Rouse, *Art: Meaning, Method, and Media* (Chicago: Benefic Press, 1981); S. Madeja and S. Onuska, *Through the Arts to the Aesthetic: The CEMREL Aesthetic Education Curriculum* (St. Louis:

CEMREL, 1977); and SWRL, *SWRL Elementary Art Program* (Los Alamitos, CA: SWRL, 1974).

7. See, e.g., Jerome Bruner, *The Process of Education* (Cambridge, MA: Harvard University Press, 1960).

8. See, e.g., Stephen Mark Dobbs, ed., *Research Readings for Discipline-Based Art Education: A Journey Beyond Creating* (Reston, VA: National Art Education Association, 1988).

9. M. Day, E. Eisner, R. Stake, B. Wilson, and M. Wilson, *Art History, Art Criticism. and Art Production: An Examination of Art Education in Selected School Districts* (Santa Monica, CA: Prepared by the Rand Corporation for the Getty Center for Education in the Arts, 1984).

10. Getty Center for Education in the Arts, *Beyond Creating.*

11. Ralph A. Smith, *Excellence in Art Education.*

12. Council of Chief State School Officers, *Arts, Education and the States: A Survey of State Education Policies* (Washington, D.C.: Council of Chief State School Officers, 1985).

13. Allan Bloom, *The Closing of the American Mind* (New York: Simon and Schuster, 1987).

14. E. D. Hirsch, Jr., *Cultural Literacy: What Every American Needs to Know* (Boston: Houghton Mifflin, 1987).

15. Lynne V. Cheney, *American Memory: A Report on the Humanities in the Nation's Public Schools* (Washington, D.C.: National Endowment for the Humanities, 1987).

16. See, e.g., P. DiMaggio, M. Useem, and P. Brown, *Audience Studies of the Performing Arts and Museums: A Critical Review* (Washington, D.C.: National Endowment for the Arts, 1978).

17. See, e.g., *American and the Arts 1984* (New York: Philip Morris, Inc., 1984).

18. J. P. Robinson, et. al., *Survey of Public Participation in the Arts: 1985 Vol. I, Project Report* (Washington, D.C.: National Endowment for the Arts/University of Maryland, 1987).

19. National Endowment for the Arts, *Five-Year Planning Document, 1990-1994* (Washington, D.C.: NEA, 1988): 87.

20. Richard J. Orend, *Socialization in the Arts* (Washington, D.C.: National Endowment for the Arts, 1987).

21. National Endowment for the Arts, *Toward Civilization: A Report on Arts Education* (Washington, D.C.: NEA, 1988): 13.

22. John McLaughlin, ed., *Toward a New Era in Arts Education: The Inter-*

lochen Symposium (New York: American Council for the Arts, 1988).

23. See, e.g., Monroe C. Beardsley, *Aesthetics: Problems in the Philosophy of Criticism*, 2nd ed. (Indianapolis: Hackett, 1981); Harold Osborne, *The Art of Appreciation* (New York: Oxford University Press, 1970); and Ralph A. Smith, ed. *Aesthetics and Problems of Education* (Urbana: University of Illlnois Press, 1971).

24. Susanne Langer, *Mind: An Essay on Human Feeling,* Vol. 1 (Baltimore: Johns Hopkins University Press, 1967).

25. Nelson Goodman, *Languages of Art: An Approach to a Theory of Symbols* (Indianapolis: Hackett, 1976); and Nelson Goodman, *Of Mind and Other Matters* (Cambridge: Harvard University Press, 1984).

26. Also, for alternative views on the cognitive role of the arts see: Elliot W. Eisner, "The Role of the Arts in Cognition and Curriculum," in *The Art of Educational Evaluation: A Personal View* (London: The Falmer Press, 1985); and David Best, *Feeling and Reason in the Arts* (London: George Allen and Unwin, 1985).

27. Harry S. Broudy, *The Role of Imagery in Learning* (Los Angeles: The Getty Center for Education in the Arts, 1987).

28. Music Educators National Conference, et.al., *K-12 Arts Education in the United States: Present Context, Future Needs* (Reston, VA: MENC, 1986).

29. See, e.g., Paul Lehman and Richard Sinatra, "Assessing Arts Curricula in the Schools: Their Role, Content and Purpose," in John McLaughlin, ed., *Toward a New Era in Arts Education* (New York: American Council for the Arts, 1988).

30. For discussion of the status of different arts disciplines in the schools, see *Toward Civilization.*

31. Charles Fowler, *Can We Rescue the Arts for America's Children? Coming to Our Senses 10 Years Later* (New York: American Council for the Arts, 1988).

32. For examples of educational leadership on behalf of arts education at the school, district, state, higher education, and national levels, see *Toward Civilization.*

33. *Arts, Education and the States: A Survey of State Education Policies:* 6.

34. For elaboration of this point, see *K-12 Arts Education in the United States: Present Context, Future Needs.*

35. *Can We Rescue the Arts for America's Children?:* 6.

36. See, e.g., D. B. Pankratz, "Aesthetic Welfare, Government, and Educa-

tional Policy," *Design for Arts in Education* 87, no. 6 (July/August 1986): 12-24.

37. See Laura H. Chapman, *Instant Art, Instant Culture: The Unspoken Policy for American Schools* (New York: Teachers College Press, 1982).

38. Jonathan Katz, ed., *Arts and Education Handbook: A Guide to Productive Collaborations* (Washington, D.C.: National Assembly of State Arts Agencies, 1988).

39. See *Arts and Education Handbook* and Council of Chief State School Officers, *Options and Opportunities in Arts Education* (Washington, D.C.: Council of Chief State School Officers, 1985).

40. For a discussion of policy research in arts education, see D. B. Pankratz, "Toward an Integrated Study of Cultural and Educational Policy," *Design for Arts in Education* 89, no. 2 (November/December 1987): 12-21.

41. See e.g., Special Issue, "Advocacy: Substance or Fluff?" *Design for Arts in Education* 87, no. 2 (November/December 1985); and Stephen Kaagan and Sarah Chapman, "Adopting Strategies for Advocacy and Action in Arts Education," in John McLaughlin, ed. *Toward a New Era in Arts Education.*

42. For analysis and criticism of DBAE, e.g., see Thomas Ewans, ed., *Discipline in Art Education: An Interdisciplinary Symposium* (Providence, RI: Rhode Island School of Design, 1986); and J. Burton, A. Lederman, P. London, eds. *Beyond DBAE: The Case for Multiple Visions of Art Education* (North Dartmouth, MA: SMU, 1988).

43. This typology is based on an article by Paul Duncum: "What, Even Dallas? Popular Culture Within the Art Curriculum," *Studies in Art Education* 29, no. 1 (Fall 1987): 6-16.

44. See, e.g., Matthew Arnold, 1869, *Culture and Anarchy,* ed. by J. Dover Wilson (Cambridge: University Press, 1971); T.S. Eliot, *Notes Towards the Definition of Culture* (New York: Harcourt, Brace and Co., 1949); and Raymond Williams, *Culture and Society, 1780-1950* (London: Chatto and Windus, 1958).

45. See, e.g., G. Chalmers, "Art Education as Ethnology," *Studies in Art Education* 23, no. 3 (1981): 6-14; and J. K. McFee, "Cross-Cultural Inquiry into the Social Meanings of Art: Implications for Art Education," *Journal of Multi-Cultural and Cross-Cultural Research in Art Education* 4, no. 1 (1986): 6-16.

46. See, e.g., P. Bourdieu, *Reproduction in Education, Society and Culture* (Beverly Hills: Sage Publications, 1977); and Janet Wolff, *Aesthetics and*

the Sociology of Art (London: G. Allen and Unwin, 1983).

47. See, e.g., Monroe C. Beardsley, "Aesthetic Welfare, Aesthetic Justice, and Educational Policy," *Journal of Aesthetic Education* 7, no. 4 (1973): 49-61.

48. See, e.g., Another Standard, *Culture and Democracy: The Manifesto* (London: Comedia, 1986).

49. Harry S. Broudy, *The Role of Imagery in Learning.*

50. See, e.g., Remarks by Michael Parsons at a Getty Center Invitational Seminar in Hermine Feinstein, ed. *Issues in Discipline-Based Art Education: Strengthening the Stance, Extending the Horizons* (Los Angeles: Getty Center for Education in the Arts, 1988).

51. For further discussion, see L. H. Chapman, *Instant Art, Instant Culture.*

52. For further discussion, see J. H. Davis and M. J. Evans, *Theatre, Children and Youth* (New Orleans: Anchorage Press, 1987); and Judith-Kase Polisini, ed., *Creative Drama in a Developmental Context* (Lanham, MD: University Press of America, 1985).

53. Harlan Hoffa, "The History of the Idea," in Stanley J. Madeja, ed., *Arts and Aesthetics: An Agenda for the Future* (St. Louis: CEMREL, 1977): 61.

54. Richard Courtney, *The Quest: Research and Inquiry in Arts Education* (Lanham, MD: University Press of America, 1987): 7.

55. Bennett Reimer, "Toward a More Scientific Approach to Music Education Research," *Council for Research in Music Education* Bulletin no. 83 (Summer 1985): 1.

56. See, e.g., NEA's *Toward Civilization* and the Getty Center-sponsored *Art History, Art Criticism, and Art Production.*

57. See, e.g., William A. Firestone, "Meaning in Method: The Rhetoric of Quantitative Research," *Educational Researcher* 16, no. 7 (October 1987): 16-21.

58. John K. Smith and Louis Heshuius, "Closing Down the Conversation: The End of the Quantitative-Qualitative Debate Among Educational Inquiriers," *Educational Researcher* 15, no.1 (January 1986): 8.

59. Ibid: 11.

60. Ibid: 11.

61. See, e.g., Clifford K. Madsen and Carol A. Prickett, eds., *Applications of Research in Music Behavior* (Tuscaloosa: University of Alabama Press, 1987).

62. Jack A. Taylor, "Forum," *Journal of Research in Music Education* 35,

no. 2 (1987): 68.

63. See, e.g., Patti J. Kreuger, "Ethnographic Research Methodology in Music Education," *Journal of Research in Music Education* 35, no. 2 (1987): 69-77.

64. For a detailed discussion of this trend, see Linda F. Ettinger, "Styles of On-Site Descriptive Research: A Taxonomy for Art Educators," *Studies in Art Education* 28, no. 2 (1987): 79-95.

65. Ibid.

66. Elliot W. Eisner, "The Primacy of Experience and the Politics of Method," *Educational Researcher* 16, no. 5 (June/July 1987):18.

67. John J. Jagodinski, "Art Education as Ethnology: Deceptive Democracy or a New Panacea?" *Studies in Art Education* 23, no. 3 (Spring 1984): 5-9.

68. D. Jack Davis, "From Research to Practice," *Design for Arts in Education* 88, no. 5 (May/June 1987): 19.

69. Ibid.: 19.

70. Vincent Lanier, "Misdirections and Realignments," in D. Blandy and K. G. Congdon, eds., *Art in a Democracy* (New York: Teachers College Press, 1987).

71. Morris Weitz, "Research on the Arts and in Aesthetics," in Stanley J. Madeja, ed., *Arts and Aesthetics: An Agenda for the Future.*

72. See, e.g., Jon W. Sharer, "Definitions: The Gift Horse of Research," *Review of Research in Visual Arts Education* no. 13 (Winter 1981): 44-47.

73. Margaret K. DiBlasio, "The Troublesome Concept of Child Art: A Threefold Analysis," *Journal of Aesthetic Education* 17, no. 3 (Fall 1983): 73.

74. See, e.g., Arthur D. Efland, "Changing Conceptions of Human Development and Its Role in Teaching the Visual Arts," *Visual Arts Research* 11, no. 1 (Spring 1985): 105-119.

75. D. N. Perkins and Howard Gardner, "Why Zero? A Brief Introduction to Project Zero," *Journal of Aesthetic Education* 22, no. 1 (Spring 1988): ix-x.

76. See, e.g., David Henry Feldman, "The Concept of Non-universal Developmental Domains: Implications for Artistic Development," *Visual Arts Research* 11, no. 1 (Spring 1985): 82-89; and Karen A. Hamblen, "Artistic Development as a Process of Universal-Relative Selection Possibilities," *Visual Arts Research* 11, no. 2 (Fall 1985): 69-83.

77. Jean C. Rush and Jessie Lovano-Kerr, "Aesthetic Education Research,

Teaching Art, and Harvard Project Zero: Some Observations," *Journal of Aesthetic Education* 16, no. 4 (Winter 1982): 88.

78. Howard Gardner, "Toward More Effective Arts Education," *Journal of Aesthetic Education* 22, no. 1 (Spring 1988): 160.

79. For detailed descriptions of these projects, see Howard Gardner, "Toward More Effective Arts Education."

80. See Laura H. Chapman, *Instant Art, Instant Culture.*

81. See, e.g., Elliot W. Eisner, *Cognition and Curriculum* (New York: Longman, 1982); J. Terry Gates, ed., *Music, Society, and Education in the United States* (Tuscaloosa: University of Alabama Press, in press); Richard Courtney, *The Dramatic Curriculm* (New York: Drama Book Specialists, 1980); and Richard J. Kraus and Sarah Chapman, *The History of Dance in Art and Education,* 2nd edition (Englewood Cliffs, NJ: Prentice-Hall, 1981).

82. Brent Wilson, *Art Education, Civilization and the 21st Century: A Researcher's Reflections on the National Endowment for the Arts' Report to Congress* (Reston, VA: National Art Education Association, 1988).

83. Elliot W. Eisner, "Alternative Approaches to Curriculum Development in Art Education," *Studies in Art Education* 25, no. 4 (Summer 1984): 259-264.

84. See, e.g., J. Beethoven, et.al., *World of Music* (Morristown, NJ: Silver, Burdett and Ginn, 1988); E. B. Meske, et.al., *Holt-Music* (New York: Holt, Rinehart and Winston, 1988); Laura H. Chapman, *Discover Art* (Worcester, MA: Davis Publications, 1985); American Association of Theatre for Youth/American Association for Theatre in Secondary Education, *A Model/Drama Theatre Curriculum: Philosophy, Goals and Objectives* (New Orleans: Anchorage Press, 1987); and S. Madeja and S. Onuska, *Through the Arts to the Aesthetic: The CEMREL Aesthetic Education Curriculum* (St. Louis: CEMREL, 1977).

85. See, e.g., Brent Wilson's content analysis of state arts education curriculum guides in *Toward Civilization.*

86. For discussion of the "operational curriculum," see Elliot W. Eisner, "Alternative Approaches to Curriculum Development in Art Education."

87. Holmes Group, *Tomorrow's Teachers: A Report of the Holmes Group* (East Lansing, WI: The Holmes Group, Inc., 1986).

88. Carnegie Forum on Education and the Economy, *A Nation Prepared: Teachers for the 21st Century* (New York: Carnegie Corporation, 1986).

89. See, e.g., Marilyn Zurmuehlen, "Educating Art Teachers: A Faculty

Response to the Holmes Group Agenda," *Visual Arts Research* 14, no. 1 (Spring 1988): 60-65; and Kathryn A. Martin and Jerrold Ross, "Developing Professionals for Arts Education," in J. McLaughlin, ed., *Toward a New Era in Arts Education: The Interlochen Symposium.*

90. M. Day, et. al., *Art History, Art Criticism, and Art Production: An Examination of Art Education in Selected School Districts.*

91. See, e.g., Bruce Jennings, "Policy Analysis: Science, Advocacy, or Counsel," in S.S. Nagel, ed., *Research in Public Policy Analysis and Management, Volume 4* (Greenwich, CT: JAI Press, 1987).

92. See, e.g., M. Brand, "Music Teachers Versus Researchers: A Truce," *Bulletin of the Council for Research in Music Education* no. 80 (Fall 1984): 1-13.

93. See, e.g., Bennett Reimer, "Toward a More Scientific Approach to Music Education Research."

94. See, e.g., M. Brand, "Music Teachers Versus Researchers: A Truce."

95. See, e.g., Jean C. Rush, "Does Anyone Read 'Studies' Any More?" *Studies in Art Education* 25, no. 3 (Spring 1984): 139-140; and Robert Colby, "From the Editor," *Children's Theatre Review* 34, no. 2 (April 1985): 2.

96. Jack A. Taylor, "The Gap Between Music Research and Music Teaching," *Design for Arts in Education* 88, no. 5 (May/June 1987): 27.

97. Laura H. Chapman, *Instant Art, Instant Culture: The Unspoken Policy for American Schools* (New York: Teachers College Press, 1982): 103.

98. Joseph LaChapelle, "Conflict Between Research and Practice in Art Education: A Sociological Perspective," *Studies in Art Education* 23, no. 2 (Winter 1982): 56-64.

99. G. L. Kneiter and J. Stallings, eds., *The Teaching Process and Art and Aesthetics* (St. Louis: CEMREL, 1979): 6.

100. Laura H. Chapman, *Instant Art, Instant Culture*: 109.

101. Charles A. Elliot, "Comments From the Editor," *Update: The Applications of Research in Music Education* 1 (May 1982): 2.

102. D. Jack Davis, "From Research to Practice": 18.

103. John Grashel, "Education is the Key," *Music Educators Journal* 75, no. 1 (September 1988): 5-6.

104. H. S. Broudy, "Theory and Practice in Aesthetic Education," *Studies in Art Education* 28, no. 4 (Summer 1987): 203.

105. D. Jack Davis, "From Research to Practice" : 18.

106. Laura H. Chapman, *Instant Art, Instant Culture* : 112.

107. See, e.g., Jean C. Rush, W. Dwaine Greer, and Hermine Feinstein, "The Getty Institute: Putting Educational Theory into Practice," *Journal of Aesthetic Education* 20, no. 1 (Spring 1986): 85-95.

108. See, e.g., Elliot W. Eisner, "Can Educational Research Inform Educational Practice?" in E. W. Eisner, *The Art of Educational Evaluation: A Personal View* (London: The Falmer Press, 1985).

109. D. B. Pankratz, "Toward an Integrated Study of Cultural and Educational Policy," *Design for Arts in Education* 89, no. 2 (November/December 1987): 14.

110. See, e.g., Irwin Feller, *Universities and State Governments: A Study in Policy Analysis* (New York, Praeger, 1986).

111. See, e.g., Ronald N. MacGregor, "Dialects and Dialectics: Thoughts on the Languages of Research," *Studies in Art Education* 23, no. 3 (Spring 1984): 4-5.

112. See, e.g., Center for Education Statistics, "Public School District Policies and Practices in Selected Aspects of Arts and Humanities Instruction" (Washington, D.C.: U.S. Department of Education, February 1988); Council of Chief State School Officers, *Arts, Education and the States: A Survey of State Education Policies* (Washington, D.C., CSSO, 1985); R. L. Erbes, *Certification Practices and Trends in Music Teacher Education 1985-86* (Reston, VA: Music Educators National Conference, 1986); E. A. Mills and D. R. Thompson, *A National Survey of Art(s) Education, 1984-85: A National Report on the State of the Arts in the States* (Reston, VA: National Art Education Association; National Assessment of Educational Progress, *Music 1971-79: Results From the Second National Music Assessment* and *Results From the Second National Art Assessment* (Denver: Education Commission of the States, 1981); M. Pappalardo, "A Long-Range Study of Dance Programs in the Public School Systems of the United States, Grades 7 through 12: A Draft Report" (Reston, VA: National Dance Association, 1987); and Daniel V. Steinel, *Arts in Schools: State by State, Second Edition* (Reston, VA: Music Educators National Conference, 1988).

113. Stanley S. Madeja, "Structuring a Research Agenda for the Arts and Aesthetics," in S. Madeja, ed. *Arts and Aesthetics: An Agenda for the Future* (St. Louis: CEMREL, 1977): 374.

114. National Endowment for the Arts, *Report of the Task Force on the Education, Training, and Development of Professional Artists and Arts Educators* (Washington, D. C.: NEA, 1978).

115. Charles Fowler, ed., *An Arts in Education Sourcebook: A View from the JDR 3rd Fund* (New York: JDR 3rd Fund, 1980).

116. See, e.g. Ruth H. DeHoog, "Theoretical Perspectives on Contracting Out for Services," in G. C. Edwards, ed. *Public Policy Implementation* (Greenwich, CT: JAl Press, 1984).

117. Charles Fowler, "Outside Funding, Policy, and Control in Arts Education," *Journal of Arts Management and Law* 17, no. 4 (Winter 1988): 57-66.

118. Ibid: 59.

119. Elliot W. Eisner, "Thoughts on an Agenda for Research and Development in Arts Education," in Stanley S. Madeja, ed., *Arts and Aesthetics: An Agenda for the Future* (St. Louis: CEMREL, 1977).

120. Stanley S. Madeja, ed., *Arts and Aesthetics: An Agenda for the Future*.

121. *Toward Civilization*: 117.

122. Hermine Feinstein, ed., *Issues in Discipline-Based Art Education: Strengthening the Stance, Extending the Horizons* (Los Angeles: Getty Center for Education in the Arts, 1988).

123. Hermine Feinstein, "Introduction," in H. Feinstein, ed. *Issues in Discipline-Based Art Education*: ix.

124. Don I. Phillips, "Introduction: The Future of Academic Research," in D. I. Phillips and B. S. P. Shen, eds., *Research in the Age of the Steady State University* (Boulder, CO: Westview Press, 1982).

125. See, e.g., David Eli Drew, *Strengthening Academic Science* (New York: Praeger, 1985).

CHARACTERIZING CIVILIZATION: Research Strategies, Findings and Implications from the National Endowment for the Arts' Report on Arts Education

by Brent Wilson

Imagine being given the task, to be completed in a few short months, of conducting research and writing a first draft for a congressionally-mandated National Endowment for the Arts report in which arts education in the United States is to be characterized. From those characterizations, recommendations for governmental policy in the areas of curriculum, assessment, research, teachers, leadership and the structure of arts education are to be made. In the spring of 1988, the National Endowment for the Arts delivered to the President and Congress a report on the status of arts education in the United States. In this paper, I will outline some of the research problems encountered as I undertook the task of gathering information and writing a draft of *Toward Civilization: A Report on Arts Education,* and I will reflect upon the processes used to arrive at some of the report's major findings, conclusions, recommendations and implications. I wish also to pay particular attention to the portions of the report directed toward research in arts education.

CAPTURING THE MONUMENTAL TOTALITY OF THE INCOHERENT

Art education in the United States cannot be characterized as something singular and particular. There has never been a national curriculum, and

Brent Wilson is a professor and head of the Graduate Program in Art Education in the School of Visual Arts at the Pennsylvania State University. In 1987 he served as a consultant to the National Endowment for the Arts.

local control of the schools is prized nearly as highly as freedom of speech. The degree of curricular autonomy varies greatly among the fifty states. Each has a unique history of support for the arts; each to one degree or another allocates a part of its statutory and regulatory authority to local school districts, local school administrators and individual teachers. The department of education in Colorado, for example, is prohibited by the state constitution from making any curricular prescriptions for local school districts, while the department of education in North Carolina has over 800 pages of specific instructional outcomes for the arts which local school districts are mandated to achieve.

In practice, most of the decisions regarding arts curricula in this country are made by the 50,700 visual arts teachers, 79,100 music teachers, 182,700 language arts teachers, 873,300 general elementary classroom teachers and an inestimable number of others who teach one or more of the other arts. And if decentralization were not enough, there are five major art forms taught in the schools — creative writing, dance, music, theater and drama, and the visual arts (to which several other art forms such as video and cinema, architecture and the design arts might also be added) — each of which is at a different state of development within our educational systems and has its own distinct history, traditions, set of purposes, curricula and instructional practices. Arts education in the United States is both diffuse and mind-bogglingly complex. How does a researcher paint a qualitatively and quantitatively accurate picture of arts education in the U.S.? How are the arts educational policies and practices to be adequately characterized?

Perhaps arts education in the United States does reflect a *zeitgeist,* a spirit of our time; perhaps it even exhibits a general national character. But general similarities notwithstanding, with such irregular and variable practices, it is no wonder that when writers have been called upon to characterize arts education in the U.S., they have traditionally resorted to describing the programmatic prescriptions found in the publications of prominent arts educators. These paperbound utopian visions of arts education, however, have precious little relationship to the garden variety of arts instruction practices in the nearly 16,000 school districts and hundreds of thousands of arts classrooms across the country. Our task in preparing the report was to present a panoramic sketch of arts education as both promised and practiced. Here is what we did.

THE STATUS OF ARTS EDUCATION
IN THE UNITED STATES: AN OVERVIEW

The Statistics

In our report we used data collected through the Fast Response Survey System of the U.S. Department of Education's Office of Educational Research and Improvement. The Fast Response Survey yields data representative of approximately 15,200 operating school districts in the United States, 75 percent of which have student enrollments of under 2,500 students. From the survey we were able to report:

- That between 1982 and 1987 the proportion of districts having graduation requirements specifically in the arts rose from 18 percent to 36 percent.

- That the number of seventh- and eighth-grade students enrolled in arts classes is much lower than we might have expected. Only 48 percent of the students take general music (81 percent in the Northeast and 21 percent in the West). Fifty-three percent of seventh- and eighth-grade students enroll in art classes (79 percent in the Northeast and 35 percent in the West); and only 14 percent enroll in other arts courses.

- Sixteen percent or fewer of the students in grades eleven and twelve take a course in general music (9 percent), instrumental music (14 percent), choral music (12 percent), visual arts (16 percent) and the other arts (13 percent).

- Only 26 percent of the elementary schools in the U.S. are served full-time by visual arts specialists; 32 percent are served part-time, and 42 percent are not served at all. In music, 45 percent of elementary schools are served full-time by specialists, 39 percent are served part-time, and only 16 percent are not served at all.

- For the visual arts, 67 percent of the districts with elementary schools reported having adopted curriculum guides that specify instructional goals in terms of student outcomes, 72 percent for the junior high level, and 74 percent for the senior high level. For music, three-fourths of the districts had guides for each level. For the other arts (dance, drama and creative writing) 35 percent had adopted guides for the elementary level, 38 percent for the junior high level, and 50 percent for the senior high level.

- Almost no districts require competency tests in the arts for promotion from one grade to the next (4 to 7 percent), although this finding does not imply that individual courses in the arts are not competency based.

- Districts' use of a list of required or recommended textbooks for the

visual arts ranged from 37 percent at the elementary level to 43 percent at the senior high level. For music, just over half had text lists for the elementary and junior high levels. At the senior high level, 46 percent had text lists. For the other arts, the proportion having text lists ranged from 23 percent at the elementary level to 33 percent at the senior high level.

– About half the districts had curriculum coordinators for the visual arts (51 to 54 percent) and music (56 percent) at each level. For the other arts, about one-third of the districts had coordinators, with percentages ranging from 30 percent at the elementary level to 38 percent at the senior high level.

The Qualitative Picture

The Kindergarten and the Elementary Grades. We knew that we could present our characterization of arts education through statistics, requirements and mandates; we also knew that the reader would have almost no idea regarding the practice of arts education. Consequently we presented a parallel account – a narrative, a story of life in the arts classroom. Our original plan was to take one child – a composite child – and move him or her through our American system of arts schooling. We thought that by following this hypothetical student through the schools we would be able to convey information about the great variety of situations, conditions, teachers, practices and policies that students encounter as they move from grade to grade and from school to school. We wanted to take him to different parts of the country, make her gifted, give him private lessons, take her on a trip to an art museum, have a visiting artist come to his classroom, describe her lessons with different types of teachers, place him within different social and economic groups; we wanted to describe the look, smell and character of arts classrooms and arts programs and the way the arts are situated within the total school curriculum.

We discovered that it would have taken us years to paint this child's-eye view. We did, however, manage to portray life in the classroom from the perspective of the teacher and from our own perspective. We characterized the child's life in art before kindergarten and then illustrated what it is like to be in a Tennessee kindergarten that still reflects Froebel's garden of children who are nurtured through arts activities throughout the day. And we indicated that these traditional kindergartens are vanishing with the onslaught of rigid reading-readiness activities and mind-numbing worksheets. We pictured the life of a Pennsylvania elementary school art teacher who meets twenty-eight classrooms of children a week. Moving to rural Idaho, we illustrated how very little of any of the arts is taught when the arts

are the sole responsibility of the classroom teacher, and we showed, when they *are* taught, how inartistic the arts can be. We visited an Oklahoma elementary school "filled with music," where the morning assembly and a weekly radio program provide the musical ingredient that flavors the entire school. We went to the Delaware Valley to observe a program in which 700 parents and other interested adults carry reproductions of works of art to schools in three states. We were pleased that they cared, but concerned when it was reported that they were engaged in their project because art teachers either did not wish to teach about works of art or were not prepared to do so. We observed inner-city children learning about the architecture of their neighborhood, and Texas children transformed by drama. And as the children moved through the elementary grades we watched the time devoted to the arts become less and less and less.

The Middle School and Junior High School. We told how art and music teachers sometimes struggle, and at other times do not even attempt, to achieve a balance between creative and productive activities. We characterized the way a general music teacher in Ohio conveyed the inter-connectedness of our music heritage — of Copland's use of the Shaker hymn "Simple Gifts" in his *Appalachian Spring* — to students who were quite satisfied with "their own music." We followed the recruitment process for school bands and showed how, ironically, because students spend an entire year practicing six or seven pieces of music about which they are taught little more than how to perform, sometimes the marching bands that sound and appear to the public to be the best, provide the least satisfactory education. We noted that the junior high school art classroom was the place to coil a clay pot, paint a landscape in watercolor, draw a still life in charcoal, make a linoleum block relief print and enamel copper jewelry, but that as few as four of fifty-four periods might be spent studying Impressionism, Post-Impressionism or anything else of the artistic heritage.

The High School. We visited a magnet high school for the arts in Wisconsin in which highly interested and talented students receive a superb education in their special art, and we cited the concern of arts teachers that these magnet schools may siphon off the students and teachers who could enrich the arts programs in other high schools. We found one Minnesota high school that offered 104 courses related directly to the arts — offerings made possible because of a seven-period day (and three more co-curricular periods added to them) and a school year divided into trimesters. In a given trimester as many as 40 percent of the student body might be enrolled in arts classes. We charted the struggles of the school literary magazine, the problems of maintaining dance programs in high schools, emerging film, television and radio programs, how dance as an art form is virtually nonex-

istent in the schools, how aerobic exercise is considered to be dance in many schools, and we reported what happened in a school district when a visiting artist, the playwright Mark Medoff, was surprised by the quality of the production of his play, *Children of a Lesser God*. We investigated and reported on the kind of model that advanced placement courses might provide for high school arts curricula.

Conclusions. When we were finished with our survey and our series of vignettes of life in the arts classrooms of the nation, we concluded that arts education in America is characterized by *imbalance, inconsistency* and *inaccessibility*. There is a curricular and instructional imbalance tilted in favor of the creation and performance of the arts rather than the study of the arts. There is inconsistency in the arts education that students receive in various parts of the country, in different school districts within states, in different schools within a single school district, and even within a single school. And because of the time pressures within the school day, comprehensive and sequential arts education is inaccessible except to a very few, often only to those with talent or a special interest in art.

FROM CONDITIONS TO COMMITMENTS

Obviously there are many reasons for the inadequacies of arts education in the United States. Some derive from the fact that ours is a society in which education is viewed as job preparation and skill acquisition in so-called basic subjects. But the inadequacies are also to be found in arts education itself, and to arrive at our insights we had to rely not so much on data as on an analysis of features of arts curricula, arts assessment, teachers of the arts, leadership and the structure of the organizations that affect arts education, and research in arts education. We undertook a content analysis of state curriculum guides; we reviewed assessment and evaluation procedures; conducted a critical analysis of educational leadership practices as they relate to arts education; constructed a model of the structure of arts education and the relationships that exist among the organizations and institutions in the different sectors of arts education; and analyzed and characterized the current status of research in arts education. In writing the report, we were often compelled, out of necessity, to rely on critical assessment alone when it would have been advantageous to base our analyses on a solid base of empirical data relating to arts education and the conditions that surround it. The lack of data notwithstanding, here is an overview of our analyses.

Arts Curricula. The curricular writings of American visual arts educators are known and admired throughout the world. Therefore, when

educators from other countries visit classrooms in the U.S., it comes as a shock to find that the grand theoretical vistas painted by our theoreticians have not been redrawn into the detailed road maps needed to guide everyday practice. Indeed, there is a remarkable gap in arts education between the goals posited and the curricular and instructional practices directed toward their achievement. Most curriculum guides created by committees at the state and local district levels are completed with a minimum of time and resources. Consequently they are frequently copied from other guides. Thus arts curriculum guides tend to be among the most conservative of educational documents. The elements and principles of design and music that found their way into guides in the early part of the century are still there. And the use of elements and principles draws attention away from what should probably be the principal content of arts education: works of art and their themes, subjects, symbols, styles, expressive characteristics, societal contexts, histories, meanings and interpretations. These guides chop "content" into minute instructional objectives relating to discrete elements and skills while ignoring the more important need to understand works of art as whole entities. We also found that curriculum guides infrequently name the important works of art that should comprise the foundation of arts literacy.

There is a paucity of resource materials for teaching the arts, except perhaps in the area of music. We reviewed the processes involved in the creation of the music texts used from kindergarten through grade eight—the years of writing, the teams of authors, illustrators and editors, the hundreds of special recordings, and the millions of dollars in resources, and then we pointed out that most arts teachers are expected to organize similar teaching resource materials by themselves with little financial assistance after they have taught for a full day. Arts curricula are in crisis.

Testing, Assessment and Evaluation. We concluded that there is almost no information available regarding what students are learning in the arts; nor is there information relating to the evaluation of arts programs. There has been no National Assessment of Educational Progress conducted since the late 1970s and some of the results from the last assessment relating to art are still unscored and have not been released to the public. Nowhere in the country could we find a program of systematic formal assessment of student achievement in the arts nor could we find instances of comprehensive data-based arts educational program assessment. There are, of course, unique problems in assessing arts students and programs, including the lack of standard content, curricula, texts, and instructional resources. Moreover, the arts do not lend themselves to easily scorable testing formats, and many arts educators dispute the wisdom of formal testing and assess-

ment. In our report we conclude that the reformation of arts education will depend upon the development of systematic procedures for arts assessment and evaluation.

Teachers of the Arts. At the elementary school level the arts are frequently taught by general classroom teachers, many of whom have little or no educational background in the arts. Arts specialists, on the other hand, usually have extensive education in their discipline and in how to teach it. In many instances, however, these special teachers have received most of their arts education in creation and performance. Most visual arts teachers working in the schools today, for example, received their education when creative expression was the touchstone, and creativity was thought best encouraged through the absence of constraint. Technique, processes and skills were to be learned through individual experimentation. Working in the mode or style of another artist was thought to be cheating. Art history was something quite unrelated to the making of art, and art criticism was limited to the critique of students' creative products. These teachers will have a difficult time teaching the broadened visual arts curricula that are presently being proposed.

What are the prospects of arts teachers changing their instructional practices? Do they have access to the information and assistance that they need to develop professionally? Few arts teachers belong to professional associations relating to arts education. Consequently, they do not have ready access to professional literature, and since only about half of the districts in the nation have arts supervisors, teachers have almost no means of receiving information and assistance regarding current developments in their profession.

Educational Leadership and the Structure of Arts Education. Although state legislatures, state boards of education and local school districts have the statutory responsibility to establish the laws, regulations, policies, curriculum mandates and standards that govern arts education, it has been the arts educators themselves who, throughout much of this century, have had to assume most of the responsibility for advocating, justifying and implementing arts education programs. Yet, although they have frequently been alone in their battles within the educational establishment, arts educators have powerful allies outside the establishment. Arts advocacy organizations, trusts and arts institutions, and passionately interested citizens form not only a strong lobby in support of arts education, but they sometimes undertake arts educational reform themselves. These efforts from outside the educational establishment, sometimes organized to subvert it, have little chance of succeeding unless they are adopted by the establishment. Exter-

nal reform efforts tend to disappear with the termination of external money.

In the report we show the relationships among the various organizations within the structure of arts education, and we conclude that if arts education is to be strengthened, then it will require the leadership, support, cooperation and coordination of each of the organizations within the structure. We indicated that as we undertake the process of reforming arts education, we must cease pointing to one or only a few factors that need correction. Each of us must stop pointing to his favorite culprit and putting all our bets on one panacea. It doesn't help much to say, "The teachers are the problem" or "The curriculum needs to be improved" or "If only administrators would . . ." "The federal government should . . ." "State boards of education must. . . ." "If only we had better advocacy. . . ." "We need more testing. . . ." "We must have better research. . . ." It is all of these things and more, and all of them at once.

In order to bring about change, state legislatures, school boards and school administrators will have to work in cooperation with professional arts associations, teacher education institutions, and national, regional, state and local arts organizations, with advocacy groups, with publishers of arts educational resource materials and commercial suppliers of arts educational materials. There is a symbiotic relationship among all of these associations and institutions that has gone largely unrecognized, and worthwhile change will occur only when there is a concerted effort by everyone, working together. In the report we have indicated the special role that the National Endowment for the Arts should play in mobilizing these organizations and agencies. If Congress supports the recommendations it could signal a new era for arts education.

RESEARCH IN ARTS EDUCATION

The role that research must play in the process of reforming arts education is crucial. Research has knowledge and understanding as its *raison d'etre*. When we know more about things, we act differently — more wisely and more insightfully — toward them. Research can and should be directed toward that full range of factors that must be activated in order to change arts education. But as things now stand it is difficult for research to play its crucial role. Not only do we lack the information necessary to characterize the present situation in arts education, but we have hardly even begun to formulate the questions necessary to direct us toward the insights we need. The issue that I would like to address relates to resources: what are the conditions under which arts educational research now functions, what research priorities should be established, and what energies should be redirected in

order to improve and expand arts education?

Conditions That Affect Research

If we examine the context in which research in arts education is undertaken, we find that most of it is conducted by university professors who juggle their research with teaching, creating, performing and directing. Since there are few federal, state or private funding sources, the research is underwritten either by the professors or by their institutions. In other disciplines, where adequate research funding is available, academic researchers are able to "purchase" release time from teaching and to hire research assistants. But researchers in arts education must add research to their already heavy schedules and work without assistants. As a result, the research tends to be fragmented, of limited scope and directed toward isolated variables that can be easily observed rather than toward larger and more complex relationships of factors that may be important, though difficult, to observe. In effect, individual researchers working relatively independently determine the arts educational research agenda.

In fields where research is extensive, research policy and direction is established either implicitly or explicitly between funding agencies (usually the government) that represent the needs of society and researchers who represent the quest for knowledge (that sometimes far outreaches the momentarily practical and useful). In arts education, where there are, relatively speaking, few researchers and virtually no financial support for research, we are faced with a situation in which a coherent research policy has had no opportunity to develop and there is no generally agreed upon sense of what research priorities ought to be.

Even if those of us in the arts were to agree upon research agenda and policies that should guide our research activities, those agenda and policies would be impossible to implement without support. It is possible, however, that if we were to outline such a policy statement, we might be better able to make the case for a vastly increased volume of sustained support. Perhaps we should debate the merits of producing an arts education research policy statement that might be useful in lobbying for a higher level of support from government and foundations.

As research directions and policies are formed, it is extremely important to consider the full range of research needs. There is often the expectation that research findings ought to be immediately applicable to the arts classroom, that research ought to relate primarily to curriculum, instruction, learning and assessment. This focus is far too narrow. We need to study the societal and economic conditions that influence the arts and arts education.

We need to understand arts teachers more fully—their degrees of professionalism, the multiple roles they play, their status within the educational and arts communities, their system of rewards (financial and professional), their conceptions of the arts, their cultural goals and values. We need more studies of educational leaders and their beliefs about the arts, the factors that lead them to support or suppress the arts. We need hundreds, perhaps thousands, of coherently organized studies of our students and how they develop artistically within society to which we need to add studies of the various ways educational factors affect students' artistic development. And finally, we need studies of the structure of arts education, of the ways that the different sectors work jointly and the ways that they sometimes work against one another. And then there are the necessary trivialities of research, the surveys and descriptive studies of programs, policies and practices, the sets of baseline data that we need in order to chart the progress or decline of arts education in our schools.

The funding by the U.S. Office of Education and the National Endowment for the Arts of arts educational research centers at the University of Illinois and New York University is a step in the right direction. But this represents only a small fraction of the financial resources needed. And there is a danger that these two efforts alone will be seen to accomplish the needed research in arts education when in truth there is a need for a broad base of funding to support research at a variety of institutions across the country.

The Philosophical and Theoretical Grounding

As we analyzed the research relating to arts education, most of which is in the areas of art and music, we found that researchers in music devoted about three-quarters of their research to studies of learner behavior and the effects of experimental treatments. Researchers in art devoted less than a fifth of their studies to problems of this nature; in recent years about two-thirds of the space in *Studies in Art Education* has been spent on the analysis and justification of the proper content of a visual arts curriculum. But even in the diversity of the two research emphases, there was a common problem. We concluded that in most cases the most important ingredient of inquiry was either hidden or perhaps missing altogether. It seems that too frequently researchers are lulled into thinking that the act of research in volves the mere collection and analysis of data, or the analysis of instructional strategies and organizational patterns. In the arts, we frequently fail to pay attention to philosophical contexts in which our assumptions about the

arts and arts education are made. It is often the case that traditional arts instructional practices that are narrow and fragmented in character determine our conceptions of art. In order to determine their utility in providing the basis for both our research and instruction, the conceptions presented to us by our philosophers of the arts should be studied and used far more thoroughly than they are now.

Let me cite an example of how narrowly we conceive the contents of our disciplines. One of the most frequent assumptions about the arts found in our research literature (and in our curriculum guides) is that any work of art is a collection of sensory and formal elements that can be isolated and studied independently. Our belief smacks of the old Pestalozzian notion of breaking down an object or a learning task into its basic components and attacking them one by one until all are learned, then putting them all together — and voila, we have learning! But as with Humpty-Dumpty after his fall, we may find that after breaking down a whole work of art into little pieces, we are unable to put them back together again, or if we do manage a reassembly, what we get may be neither a work of art nor a worthwhile experience with art.

It is possible to conceive of a work of art as a collection of formal qualities, as Fry, Fenollosa or Dow might, or as evidence of the emotional state, as Croce or Collingwood might, or as an object that calls for interpretation through which it becomes a work of art, as Danto would maintain. Or we might look at works of art as "patterns of intention," as Baxendall does, or view the work of art as a social phenomenon that reflects social values and is the carrier of ideas. The point is that works of art reveal only what we expect them to reveal; the answers we receive through our research are utterly bounded by the questions we formulate. In research in arts education we have been remiss in our question asking. Our questions have been too narrow and too uninformed by philosophies of art.

The Relationship of Research to Practice

It is naive to think that research will tell us what to do or that it will solve our arts educational problems. It is only when we have decided what we wish to accomplish that some research studies will point to ways to achieve our goals. But even when we have reasonably clear notions of what we wish to achieve in arts education, we should not expect that there will be some exquisite point-by-point match-up between research finding and practical application. Education, and especially arts education, has probably never been altered in any significant way because of the findings of research. Among the many ways of *coming to know,* research is merely one way, albeit an im-

portant one, in which we come to a greater and more complete understanding of arts education. As I have already said, when insightfully and extensively conducted, research and inquiry should result in the expansion of our cognitive orientation to a whole range of factors that affect arts education in a positive way. And when we know more we will act more wisely. But as things now stand we lack a great deal of the essential information that could make us wiser.

Frequently on far too delayed a schedule, arts education is influenced by factors in society and by changes in the world of art, art history, art criticism and the philosophy of art. When we see more clearly what our students are capable of within the whole range of artistic and aesthetic experiences, we will gradually come to change our educational practices. This process is a slow one and there are few point-for-point connections between a single or even a group of research studies and educational practices; research is only one part of the arts educational enterprise. Furthermore, we should never get the idea that research is a value-free act. Research is every bit as laden with values and human interests as are the goals of arts education. Research does not determine values and goals. It is quite the other way round: values and goals shape the research agenda. And that is as it should be.

CONCLUSION

Our current arts educational research suffers from two severe shortages: first, lack of a solid philosophical and conceptual foundation on which to build our theorizing and, second, inadequate financing to carry out a reasonably full research agenda. As we struggled to paint a comprehensive picture of arts education in the elementary and secondary schools of the United States, we became increasingly aware of how little pigment there was to cover such a large canvas and fill out its composition with the detail we desired. We simply did not have available from any source much of the information that we needed. Let us hope that the paucity of data for the current study of arts education will motivate us to formulate a comprehensive arts education research policy and to finance its practice. If we act now, the next report to the President and Congress on arts education, the one recommended by the National Endowment for the Arts for completion by the mid-1990s, can be more thorough than the current one.

THE LANDSCAPE OF EDUCATIONAL RESEARCH AND GETTY INITIATIVES

by Margaret K. DiBlasio

Hard-nosed researchers in the physical sciences tend to regard educational research as an oxymoron, like "military intelligence." Educational research observes its own slower pace and cannot offer the certainty of research done in the laboratory. The difference can be attributed to the fact that the topics of research in education — aspects of human behavior — are considerably more complex. The ruling principles of human behavior have yet to be reduced to neat mathematical formulae; they may never be so formulated, though we continue the search for regularity and predictability. I think we can agree that education in the arts deals with the most complex and subtle behaviors of all. To enter the world of the arts is to engage in activities that are value-laden and rich with allusions even as they require critical judgment; precision and control are interspersed with leaps of spontaneous expression. In the arts, cognition and feeling interpenetrate and reinforce one another. In the arts, one may oscillate between enshrining the spirit of one's culture and departing boldly from it. Researchers exploring arts education therefore face a considerable challenge from the very start.

People have different reactions to the limitations of research in arts education. Some want to scrap all such research, claiming that the pathways of teaching and learning in the arts can never be charted. According to these critics, our time and effort is better spent elsewhere. Some researchers are content to make very tiny chips in the empirical mountain, hoping that their pooled contributions in the long run will provide a sure map to the maze of human behavior. In the meantime these researchers ex-

Margaret DiBlasio is a professor in the Department of Curriculum and Instruction and head of the Art Education Program at the University of Minnesota. She is a frequent contributor to the dialogue about curriculum reform in art education and is a senior faculty member of the Getty Institute for Educators on the Visual Arts.

press trust in the validity of their findings. I include myself in a third group that accepts educational research at its present stage of development with a critical "grain of salt." By this I mean that there is a need for special care and discernment in interpreting and applying educational research. Our findings do not constitute some kind of gospel to be followed blindly; there is a need for reflection and old-fashioned wisdom in uncovering the significance of research and using it to guide us forward. For example, some of the research concerning children's drawing skills focuses on the untutored habits of youngsters rather than on what they can achieve through instruction. It takes wisdom to decide how and if such research should influence educational practice. One also needs wisdom to distinguish between substantive research and interesting, though questionable, largely unsupported hypotheses such as right brain/left brain dominance.

What sorts of educational research are being conducted? Table 1 illustrates a number of research methodologies at the disposal of educational researchers, as well as some of the leading research questions being investigated. Let me comment on five of these avenues of research.

TABLE 1: Areas of Educational Research in the Arts

		RESEARCH METHODOLOGIES				
		SURVEY/ DESCRIPTIVE	QUASI- EXPERIMENTAL	CASE STUDY	SOCIOPOLITICAL ANALYSIS	PHILOSOPHICAL ANALYSIS
RESEARCH QUESTIONS	INSTRUCTION					
	LEARNING					
	MATURATION					
	SOCIAL/POLITICAL ISSUES					
	PHILOSOPHICAL ISSUES					
	CURRICULUM DEVELOPMENT/ IMPLEMENTATION					

1. Surveys and other descriptive studies enable researchers to determine significant factors at work in a situation. At times this research assumes a diagnostic value; that is, the identification of certain factors points the way to further research, often research using a different methodology. For example, a survey of community attitudes concerning support for the arts in education may lead to the development and experimental testing of a particular strategy for influencing public opinion.

2. Educational research using controlled experiments is properly called quasi-experimental research, since it only approximates the tightly controlled laboratory conditions of the physical sciences. Nevertheless these empirical studies, like those of the sciences, depend on fragmenting the topic under study. An exceedingly complex phenomenon such as creativity must be reduced to a collection of *probable* variables. I say "probable" because the researchers must assume that the list of variables is adequate to the phenomenon. The researchers also must ensure that the sampling used in the study reflects the larger population to which the conclusions are applied. At any rate only a few of the identified variables can be manipulated within the research design. Research of this sort works best when teams of researchers are committed to the same clearly defined goals, increasing the likelihood that individual research specialties eventually will fuse to give us the "big picture" of some phenomenon.

3. Case study research is gaining in importance within the educational community. The advantage of this naturalistic approach is that the researcher confronts a topic in its immediate context. Rather than carve up the phenomenon into variables, the wholeness of the experience is preserved. In this mode, researchers use the techniques of anthropologists and sociologists to uncover the complexity of a situation and to chart patterns of behavior. In approaching a case study the researcher's perceptions are heavily conditioned by his or her prior knowledge and beliefs. This reliance on the observer's powers of discernment accounts at one and the same time for the advantages and disadvantages of this method. A knowledgeable and astute researcher may gain significant insights from case studies; less qualified researchers may end up merely reinforcing the biases that they bring to the case study. Evaluation in the arts often uses the case study approach in preference to objective testing procedures.

4. Sociopolitical analysis is applied by educational researchers to both historical and contemporary situations. Much of this research in education focuses on the institution and process of schooling as it is or has been shaped by various social, economic or political forces. Sociopolitical analysis is descriptive of complex social situations; some of it also is reform-

ist in nature. Critical theorists analyze educational decisions, including those made in the arts curriculum, in terms of struggles for power. For example, an art curriculum relying on traditional conceptions of the art heritage and established art masterpieces might be interpreted as an agency for maintaining the social and political *status quo.*

5. Philosophical analysis is an important, though often neglected channel of research. In an ideal world of research a measure of philosophical analysis would precede all research efforts, in order to resolve ambiguities of language, to clarify issues and to identify assumptions that are incorporated in the formulation of the research question. Conceptual analysis can be used to identify the unstated assumptions that a researcher makes about the nature and scope of the arts. For example, a researcher might be excluding the contemporary frontiers of the arts or emphasizing popular arts to the detriment of the arts heritage.

To what ends are educational researchers pursuing these methodologies? What are some of the research questions of concern in arts education? I shall comment on six topics of current interest.

The excellence in education movement has generated renewed interest in research concerning the art of *instruction.* What changes might arts instructors make to enhance their effectiveness as teachers? Researchers are asking:

- How do various instructional practices affect the understanding and behavior of students? For example, should instruction in the arts be more or less prescriptive?
- How do effective communication skills alter the character of instruction in the art classes? Is the teacher's ability to articulate clearly about a concept as important as the ability to demonstrate a process?
- What role does advance planning play in assuring effective instruction? Does planning inhibit spontaneity?

The counterpart of instructional research is research into the *learning* process. Researchers seek to uncover the factors that make students receptive to good teaching.

- How many kinds of learning styles can be identified in students? How can effective teaching in the arts take advantage of individual differences in learning style?
- What are the characteristics of an environment that is conducive to learning in the arts?

A perennial favorite is research concerning the process of human development or *maturation.*

- Are there natural stages that describe a progression of maturation moving from naive to sophisticated understanding and performance in the arts?
- Can the process of maturation in the arts be charted so that educators will know when to expect student readiness for new aspects of arts learning?
- What can be known about perceptual growth? For example, when do children begin to observe illusions of depth, or when do they become conscious of subtleties of movement?

Since the arts function as both determinants and expressions of culture, research in arts education must confront *social and political issues.*

- Who determines the educational values for public schooling, including the educational value that is assigned to the arts?
- What are the underlying sociopolitical forces in the debate between "excellence" and "equity" in arts programs?

In order to avoid rhetorical confrontations and to promote reasonable discussion of the issues in arts education *philosophical issues* also need to be addressed by researchers, so that meanings can be clarified, ideologies exposed and hidden assumptions brought to light. Consider how philosophical analysis might apply to questions of arts curriculum.

- There are many views of aesthetics. Some for example hold that art can be just about anything. How do different views of aesthetics affect the formation of curriculum?
- How do particular assumptions concerning the nature of arts perception, arts knowledge and arts performance affect the decisions of curriculum developers?
- What is the meaning of a quality existence that is implied in a particular curriculum? Does the urge to provide economic security for students minimize attention to human values such as awareness of the arts?

Although all educational research is conducted in the hope of eventually influencing practice, some research, that dealing with matters of *curriculum development and implementation,* is immediately practical.

- What are the most effective means for selecting curriculum objectives? Who should be involved in the decision making, and what criteria should they use in resolving conflicts?

- What is the content that should be included in order for an arts program to be considered comprehensive?
- Following a school district's decision to adopt an arts curriculum, what strategies can be demonstrated as effective in diffusing and implementing the curriculum throughout the district? In this regard, what strategies are shown to be effective in staff development?
- How do students benefit from a particular kind of arts curriculum? Can these benefits be determined through forms of evaluation?

In addition to the mainstream research questions that I have sampled, there are other ways that research can be channeled to meet the specialized needs of interest groups. Some of the research into school practices and public attitudes that is conducted to support advocacy of the arts really should be categorized as marketing research. In order to sell the arts as a generalized product, data are sought that will help identify and exploit markets for arts advocacy.

GETTY INITIATIVES

In 1982 the newly formed J.P. Getty Trust committed itself to the establishment of another Getty museum, the development of a Center for the History of Art and the Humanities and the development of a Conservation Institute. Having provided for the professional constituencies involved with studying and conserving the artistic heritage, the Trust decided also to form a Center for Education in the Arts, in order to serve individuals of all ages who constitute the audiences for the arts. A number of the programs of the Getty Center are conceived as research and development activities focusing initially on the visual arts.

The director, Leilani Lattin Duke, addressing a group of art educators in Massachusetts in 1987, explained the rationale for the Center's support of research and development programs in the discipline-based approach: "If a significant change is to occur in the way the arts are perceived by the public and the way they are taught in schools, we need to develop persuasive arguments for the role the arts can play in general education. We also need to develop quality arts education programs consonant with our convictions [of the value of art to society and to the development of the individual]."

The first research project of the Center, conducted in 1983-84, was a national case study project examining seven U.S. school districts which were attempting to teach art in a manner approaching discipline-based art education. The seven sites selected were school districts in New York, Ohio, California, Virginia, Illinois, Wisconsin and Minnesota. The executive

report of the study prepared by the Rand Corporation identifies many of the factors contributing to successful implementation of visual arts curricula. A successful school district is likely to exhibit the following characteristics in its visual art program:

- A clearly stated set of goals and objectives
- A written sequential curriculum composed of lesson plans with content from the four art disciplines
- Support from superintendents and other central office administrative personnel in school districts
- Leadership and commitment from principals
- Collaboration from museums, artists and other community cultural resources
- Staff-development programs for teachers, art specialists and school administrators
- Procedures for assessing student achievement
- Strategies for annual program review and evaluation
- Availability of adequate instructional time, space, financial resources and expert consultants

The second research initiative of the Center established the Getty Institute for Educators on the Visual Arts in Los Angeles in 1983. This pilot research and development project gave rise to a five-year program designed to study processes of staff development and curriculum implementation in DBAE. The Getty Institute's program spread to twenty-two school districts in the Los Angeles area. Each school district was expected to commit itself to district-wide implementation. Table 2 illustrates the gradual diffusion of the Institute in the Los Angeles area. At the onset a single summer training program was scheduled to serve the needs of seven school districts. By the third year the participating school districts had grown to nine; these nine districts grouped by region to conduct training in three concurrent summer programs. At the same time thirteen additional school districts were initiated into their first summer staff development program at a fourth site. In time these thirteen also divided into regional sites.

Table 3 illustrates the diffusion of leadership training within each of the participating school districts. District teams who receive training at a summer institute are brought back in the second year for a renewal program. Additional district teams begin their training at the Institute each year. In the meantime the original district team becomes the staff of the district's continuing training effort, assisting Institute faculty and extending the train-

ing throughout the district.

The Institute retained two outside evaluators, Ralph Hoepfner and Blanche Rubin. In their assessment of the Los Angeles DBAE Staff Development Institute, they identify a number of factors contributing to effectiveness:

- The commitment of superintendents and school board members to establishing and maintaining an art program as part of a balanced curriculum

- Each district's participation, involving teams composed of school board representatives, central office personnel (e.g., assistant superintendent for curriculum) and art and general classroom teachers and their principals

- A staff development program of sufficient duration to extend participants' knowledge about art

TABLE 2: Diffusion of Summer Leadership Training Programs in the Los Angeles Area

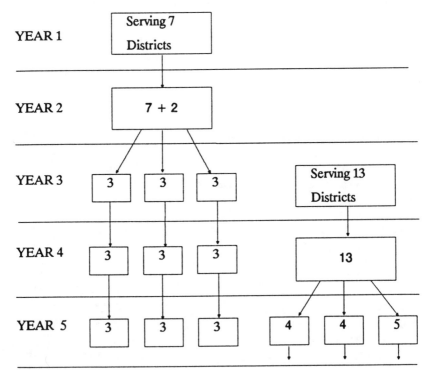

TABLE 3: Getty Institute for Educators on the Visual Arts Diffusion of Leadership Training within Individual School Districts

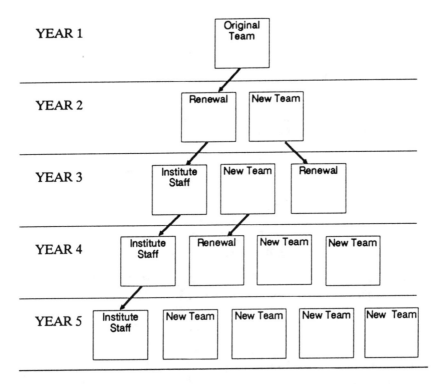

- The delivery of the content of the staff development program by art educators and by representatives of the four art disciplines (artists, art historians, art critics and aestheticians)

- The presentation of theoretical information combined with practical application demonstrations and practice teaching opportunities

- The assumption by each district's team of responsibility for developing and carrying forward their own district-wide implementation program

- The adoption of written sequential curricula selected from those available commercially or developed by the district and supplemented with instructional resources (*Curricula* as used here refers to sets of lesson plans for each grade level which are written and sequenced to encourage cumulative learning, and which present

TABLE 4: Situation Summary of Third-grade Classrooms in Participating School Districts

	Classrooms of Teachers Trained in DBAE	Classrooms of Teachers Not Trained in DBAE
Time devoted to art instruction each week	90 Minutes per week Average	Less than 60 minutes per week
Distribution of art instruction time in Scheduling	Less than half of the classrooms scheduled for Friday afternoon	80% scheduled art for Friday Afternoon
Content of instruction	About 50% of Instruction focuses on concept and skill development through art production activities; 50% focuses on other art disciplines	90% of time is spent in making art; 10% of time is focused on other art disciplines
Attention to serious art	Students look at and talk about serious art more than twice a week	No evidence of serious art on display; no time is spent talking about serious art
Persistence of holiday arts activities	Holiday projects diminished	Evidence of holiday art activities displayed in the room

content and skills from the four disciplines of art history, aesthetics, art criticism and art production.)

In another aspect of the Los Angeles Institute's external evaluation, the researchers looked for differences in classroom practice between teachers who had been trained at the Institute and those who had not. Ralph Hoepfner's statistical summary, backed up by Blanche Rubin's case studies, in Table 4 reveals the following situation in third-grade classrooms of participating school districts.

According to the Institute's director, Dwaine Greer, the effectiveness of the southern California DBAE experiment may be attributed to consistency in adhering to a single theoretical base. In preparation for the staff develop-

ment institute, experts were convened to develop a clear philosophical basis for the program. This formulation of DBAE principles was taught to teachers in summer institutes, embodied in the curricula taught to children, and maintained through continuing staff development in the school districts. Students have been tested to determine if the influences of these DBAE principles can be observed in their understanding and production of art.

More recently the Getty Center has taken initiatives to seed the development of model discipline-based art education programs in school districts around the country. We in Minnesota were fortunate to receive two district wide planning grants. The Robbinsdale, Minnesota, school district is in the second year of its implementation phase under a Getty grant. In the first summer staff development institute, more than 100 Robbinsdale teachers and administrators volunteered two weeks of vacation time to learn about the DBAE approach from experts in art education and in the four art disciplines.

It may be interesting to sample some of the first-year findings of the Robbinsdale Institute:

- In the staff development survey, 93 percent of teachers in attendance indicated that they would return for further staff development during the summer of 1988.

- In the implementation survey, it was found that teachers in all of the twelve elementary schools in the district are using the adopted DBAE curriculum (smART series) weekly. Certified art teachers alternate weekly with elementary classroom teachers in teaching from the curriculum. Under the guidance of an art curriculum specialist from the University of Minnesota, junior and senior high art teachers are currently developing and testing art curriculum materials in their classes.

- A case study is currently being conducted to determine levels of use of the DBAE curriculum, that is, the degree to which classroom instruction adheres to the conceptual structure and sequence of the curriculum.

In addition to the two school district DBAE grants that the Getty Center awarded in Minnesota, a consortium of school districts, state agencies and the university, assisted by a Getty grant, is planning for a major DBAE implementation effort extending to rural as well as metropolitan areas of the state. As can be seen in Table 5, current plans for staff development in the Minnesota consortium envision a different model of diffusion. Since the participating school districts are widely distributed throughout the state, it is an-

ticipated that in the second year staff development would be split among three regional sites, each of which is served by a state university center. In the third year each of the participating state universities would establish school sites within their regions at which students in elementary education could receive pre-service training in DBAE, as well as sites for demonstrating DBAE to elementary teachers. In the fourth year similar sites would be established at the secondary level.

Getty grants awarded in Minnesota already have stimulated state agencies to collaborate in staff development endeavors. In order to facilitate the Minnesota DBAE initiative, a state funded arts resource agency has sponsored a number of ventures relating to DBAE. A summer institute at the University of Minnesota, funded by the resource center, provided DBAE training for teams from fifteen school districts across the state. In the following summer thirty-five secondary art teachers were funded to develop curriculum modules in the DBAE format. Over 200 additional art teachers attended a two-day DBAE information institute at the Spring Hill Conference Center during the spring of 1987. The Art Educators of Minnesota

TABLE 5: Minnesota DBAE Consortium - Projected Staff Development Programs, Preservice Sites and Demonstration Sites

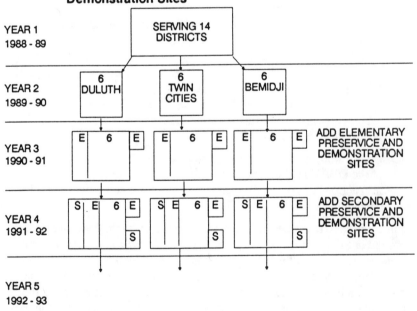

chose to focus their 1987 fall conference on DBAE issues. Over 400 art teachers have taken the opportunity to be informed by these events.

The first regional institute outside of California was established with Getty funding in Arizona under the direction of faculty at the University of Arizona. In this experiment a new factor in the dynamics of educational change came to light. The University-based director of the Institute was committed to maintaining Institute programs in conformity with DBAE principles; other state agencies wished to reconfigure the DBAE concept for regional adoption. This has given rise to a careful analysis of the mechanisms of control in educational change.

Currently a number of other states are planning for the development of experimental programs in DBAE. Eight regional sites have been awarded Getty grants to plan for regional implementation of DBAE curricula. As one of these eight planning sites, Minnesota is conducting research into the social dynamics of the process of program development and implementation.

The Getty Center has convened a number of seminars in which scholars and practitioners have examined some crucial concepts in the DBAE formulation. Sessions in Scottsdale, Arizona, and Cincinnati, Ohio, were conducted in 1986 and 1987. In January 1987, the Center introduced DBAE concepts to a national sampling of educational leaders. These meetings have been important in generating the development of major research papers analyzing DBAE concepts.

In August 1987, the Getty Center convened teams of university faculties from fifteen teacher training institutions at Snowbird, Utah. The participants, who included specialists from studio arts, art history, art criticism, aesthetics and art education, were charged with the task of analyzing the preservice component of teacher education and of recommending changes in course offerings.

Table 6 presents once more the matrix of research methodologies and questions considered earlier. Here we can locate some of the research projects either funded by the Getty Center or enabled by the existence of Getty programs. You will observe that these DBAE-related projects are fairly well distributed across the spectrum of areas of research.

Research projects funded by the Getty Center are clustered primarily at the last column and along the bottom row of the matrix. These cells represent the Center's continuing interest in promoting scholarly analysis of key concepts in the DBAE formulation, as well as a major focus in staff development and curriculum implementation. As regional DBAE institute grants

TABLE 6: Areas of Educational Research in the Arts *

		RESEARCH METHODOLOGIES				
		SURVEY/ DESCRIPTIVE	QUASI- EXPERIMENTAL	CASE STUDY	SOCIOPOLITICAL ANALYSIS	PHILOSOPHICAL ANALYSIS
R E S E A R C H Q U E S T I O N S	INSTRUCTION	■ ■	■ ■	■		
	LEARNING	■				■
	MATURATION		■ ■	■		
	SOCIAL/POLITICAL ISSUES				■ ■	
	PHILOSOPHICAL ISSUES					■ ■
	CURRICULUM DEVELOPMENT/ IMPLEMENTATION	■ ■ ■		■ ■ ■ ■ ■ ■ ■	■	■ ■

* Includes Getty-funded projects and those enabled by the existence of Getty Programs

are awarded, the number of sites for curriculum-related research will increase dramatically. Some of the questions addressed in Getty-funded research include the following:

– What factors contribute to successful DBAE staff development and curriculum implementation (case studies in curriculum implementation)?

– What is the range of issues to be addressed in developing the DBAE curriculum concept (analytic studies in art and in curriculum development)?

– What is the role of imagery in the DBAE approach to learning (philosophical analysis of the learning process)?

Other research projects shown in the matrix have been enabled by the Getty Center in the sense that their research was stimulated by Getty initiatives and that the research topics came into focus with the existence of Getty-funded programs. This sort of indirect support is an important aspect of the Getty initiatives. Independent research projects marked in the matrix reflect primarily work that is being done in Minnesota; similar projects are

under way elsewhere in the nation. Some of the questions being addressed in university-based research include the following:

- At what stage in their development can students in a DBAE program effectively engage in aesthetic reasoning (quasi-experimental study in maturation)?

- What is the effect of "prescriptive," sequenced DBAE instruction on students' creative and imaginative development (descriptive study in instruction)?

- What values are at work in the social dynamics of DBAE development and implementation (critical analysis of social issues related to schooling)?

The research efforts that I have described should not be interpreted as tactics in a drive to promote a new ideology of arts education. Research that is seriously and legitimately undertaken constitutes a quest for understanding; as such it will continually reshape its own agenda for the future. The important thing to note about research in arts education is that it has been freshly stimulated; intellectual curiosity is running high. This is a good time for arts advocates to take advantage of the insights that will be offered by continuing arts education research.

THEORY AND PRACTICE IN ARTS EDUCATION: A Report on the National Arts Education Research Center Site at New York University

by Jerrold Ross

In the traditional scheme of things, research conducted by academics is expected to be based on either the creation or the expansion of existing theory. Frequently, doctoral candidates are asked, "What is the theoretical base for your dissertation?" Just as frequently, even when faculty propose a new graduate program within the university, the most common first requirement is that they describe the theoretical base.

None of this theory can exist, of course, without reference to actual practice. Whether an examination of theory already presented, or the proposal of new theory, discussion must center on a body of existing work.

In the arts, theory has always been derived from practice. Since music is my field, the illustrations that come immediately to mind are those of "common practice" theory—theory in this case meaning not only the underlying compositional techniques created by a group of composers over a stylistic period but, as the teaching of music has grown, the actual *title* given to classes that discuss musical form and style. It would not have been possible to define the "common practice" period without the existence of a tremendous body of music. Nor would it have been possible to define "classical" compositional style without the corpus (maybe even the corpses) of Haydn, Mozart and Beethoven.

Jerrold Ross is associate dean for academic affairs in the School of Education, Health, Nursing, and Arts Professions, New York University, and director of the National Arts Education Research Center at New York University.

It has been the task of music theorists, therefore, to codify theory based on the actual musical practice of great composers. Moreover, from the time of Rimsky-Korsakov until today, composers themselves have frequently been leading theoreticians.

Once codified, however, these theories have been examined or argued, supported or opposed, confirmed or denied by scholars everywhere. In spite of controversy among scholars, the theories have taken on an aura of absolutism even though they are not absolutely firm themselves. For example, a few musical no-no's such as the use of parallel fifths or incorrect resolutions of certain dissonances, forbidden in musical exercises by theory teachers, are sometimes found in the very literature upon which the rules are based, irrespective of the deification of these same rules. Thus practice becomes isolated from theory for the sole purpose of creating a set of absolutes that make teaching the rules that much easier. (It has often been advanced that theory exists for the comfort of the teacher rather than the enlightenment of the student!) Although it cannot be denied that there *is* a range of acceptability from one stylistic period to another, theory has a way of obscuring some of the more creative efforts of the artists upon whose work the theory has been predicated.

In the opening of *Art As Experience* Dewey states:

By one of the ironic perversities that often attend the course of affairs, the existence of the works of art upon which formation of an esthetic theory depends has become an obstruction to theory about them. . . . When an art product once attains classic status, it somehow becomes isolated from the human conditions under which it was brought into being and from the human consequences it engenders in actual life-experience.[1]

In other words, the elevation of theory away from its practice base even more significantly removes it from understanding the same musical techniques designed to illustrate human conditions. And so, Dewey goes on:

A primary task is thus imposed upon one who undertakes to write upon the philosophy of the fine arts. This task is to restore continuity between the refined and intensified forms of experience that are works of art and the everyday events, doings, and sufferings that are universally recognized to constitute experience.[2]

Stravinsky, in his *Poetics of Music,* says,

Let us not forget that *Petrouchka, The Rite of Spring,* and *The Nightingale* appeared at a time characterized by profound changes that dislocated many things and troubled many minds. . . . The changes of which I

speak effected a general revision of both the basic values and the primordial elements of the art of music.[3]

It is in this context that research to be conducted by the New York University site of the National Arts Education Research Center (popularly known on our campus as NAERC) is being initiated. It is a major departure from the traditional *approach* to research and an attempt to adopt a more holistic structure. We seek to avoid the kind of educational research that is fragmented and has always seemed unclear and unfocused to policy makers.

The Center's research will be predicated on the work of excellent arts educators, beginning with twelve art and music teachers in the high schools of New York City. This summer, another twenty teachers, drawn from cities, suburbs and rural areas across the country, will be added. The research topics to be investigated will be developed jointly by the teachers and New York University faculty, aided by representatives of cultural institutions, aestheticians, critics and arts scholars. The topics will be rooted in the disciplines of art and music and will lead to studies focusing on enhancing skill development, analyzing aesthetic response, and developing critical thinking, all of which will encompass the acquisition of historical understandings drawn from each of the art forms.

Every classroom in the arts should include one or more of these elements, all of which are critical to creating an informed citizenry. For too long the unadorned study of technique has afflicted both art and music education, and past as well as current efforts designed to evaluate the "growth" of technique among boys and girls in drawing and painting classes, bands, choruses and orchestras. Devoid of the connection of technique to history, criticism and aesthetic judgment, this approach has created a nation uninformed as to the relationship between the creation of art and its apprehension.

Langer said:

A work of art is an expressive form created for our perception through sense or imagination, and what it expresses is human feeling. . . . *Everything that can be felt,* from physical sensation, pain and comfort, excitement and repose, to the most complex emotions, intellectual tensions, or the steady feeling-tones of a conscious human life.[4]

If young people are to carry away impressions, sensations, knowledge and the ability to evaluate art in terms of their own lives, then the development of skill must be *informed;* it must rely on the four areas to be engaged

by the Center. And, most important, those feelings, impressions, sensations, attitudes *and skills* will need to be derived from the practices of excellent teachers. They have always known that students must take from their classrooms the ability to understand and criticize art on their own, equipped with information which enlivens their engagement in the arts, whether as observer or participant.

Of equal importance will be the influence of cultural institutions. The art object itself is the work to be studied, whether painting, sculpture, symphony or dance. The experience of the educational arms of cultural institutions is vital to our efforts to help teachers take something in and refresh themselves, since they spend virtually their entire energies giving forth information and enthusiasm. But the cultural institutions themselves have questions as to the effectiveness of their programs, and so the Center will engage, with them, in longitudinal studies of their impact on young people. Even beyond that, we intend to explore new ways of collaboration among schools, museums, orchestras and universities. Surely the collective energies of our institutions should be able to produce the informed citizenry we all desire.

By the way, anyone familiar with the history of arts education will recall that early in this century there were superb examples of this cooperation. In Kansas City, where everything was "up to date," a music educator named Mabelle Glenn turned the educational system upside down (and, indeed, the Kansas City Philharmonic, which she deemed not adequate for her purposes) by going to St. Louis and bringing that city's orchestra players to the Kansas City schools. Like the little woman who started the Civil War, Glenn not only created a splendid program of music appreciation in the schools, but forced the Kansas City Philharmonic itself to improve. Our Center will work with the New York Philharmonic (I don't think it needs much improvement, though I often long for the conductors of my own childhood: Stokowski, Bruno Walter, even the young Bernstein). We need to overturn (turn around) the New York City Board of Education. Some of the $28 million allotted to the new schools chancellor should go for arts education.

We are already discussing with the New York State Council on the Arts ways in which program evaluation may be conducted (if you will forgive me), not with the sweep of a broad brush ("Don't the kids look happy after banging on their Orff instruments?") but with the meticulousness of the metronome! Didn't you know all the arts aspire to the condition of music?

I think we are all indebted to the American Council for the Arts for attempting to bring together representatives of the major forces in arts educa-

tion reform. Our goal should be not only to raise the level of skills, attitudes and understandings about the arts but also to elevate the aspirations of our entire society.

One of the loveliest thoughts in the literature of aesthetics was advanced by Irwin Edman. In *Arts and the Man* he said:

> ... art is the name for the whole process of intelligence by which life, understanding its own conditions, turns them to the most interesting or exquisite account.[5]

That is the task not just of the NAERC but of us all. We welcome the opportunity to be of help.

NOTES

1. John Dewey, *Art As Experience* (New York: Capricorn Books, 1958):3.
2. *Ibid.*
3. Igor Stravinsky, *Poetics of Music* (New York: Vintage Books, 1960):10.
4. Suzanne K. Langer, *Problems of Art* (New York: Scribners, 1957):15.
5. Irwin Edman, *Arts and the Man* (New York: W.W. Norton, 1939):12.

RESEARCH IN ARTS EDUCATION: An Agenda for Critical Issues

by Theodore Zernich

There is no central question that drives research in arts education. Instead, there are a series of interesting, difficult and important issues that are best viewed as interaction effects. There also are common themes that, in education, transcend the various art forms. For example, there is the hedonic question: Why do people enjoy the various arts? The cognitive question: Does intellectual growth in the arts follow a nonlinear path that is incongruent with traditional developmental research? The philosophic question: What are the roles of the arts in a highly advanced technocracy? There are many other questions, but I believe the point is clear: research in the arts is complicated, multidimensional and intricately linked to probability and to cultural values.

Research in arts education tends to focus on questions related to the participants in the process, namely, the maker, the product, the perceiver and, frequently, an intermediary such as a teacher. Arts education research attempts to identify and evaluate essential perceptual and cognitive processes that make it possible to create and respond to the arts experience. The methods and techniques of empirical or quantitative researchers differ markedly from those researchers who are more qualitatively oriented. What differentiates empirical studies of the arts from qualitative studies of the arts is not the essential thrust of the question; the difference lies in the way the question is answered. While qualitative arguments are based upon introspection and formal logic, empiricists base their arguments on systematically acquired evidence that is observable, measurable and testable. Arts education research tends to require both strategies in order to form a com-

Theodore Zernich is a professor and the associate director for the School of Art and Design at the University of Illinois at Urbana-Champaign, editor of Visual Arts Research *and was the first director of the National Arts Education Research Center at the University of Illinois.*

prehensive portrayal of the issues, and, as I will show later, the work of the Arts Education Research Center at the University of Illinois reflects this view.

Arts objects and events vary on many dimensions. It seems clear that initial learning in the arts involves sensitivity to similarities and differences along dimensions that have high cue validity. In terms of published research, two highly interactive global variables are most evident: one is represented by studies which examine structural and symbolic properties in the object or the event; the other deals with responder issues, the how, what and why of the process of perceiving and internalizing the arts experience.

While it is my intention to share several generalizations about research in arts education, it is important to keep in mind the paradox that confronts researchers interested in human behavior. First, humans share many common attributes. Second, humans are unique. Add to these points the complexity and the perhaps infinite range of arts products and events, and it quickly becomes apparent how important it is to develop carefully constructed research designs and research instruments to understand this profound act of human invention. Is significant work in arts research impossible? The answer is no because given that art is made by humans, the activity takes on normative qualities. Procedures, techniques, styles, expressions or patterns begin to reflect qualities of other works or events and to share these qualities to varying degrees. Research in arts education is a philosophical, political, psychological and social problem. Those who believe that this research represents only one of these problems will bring a limited perspective to their work. The diversity of disciplines that contribute to arts education makes it clear that no single orientation can adequately provide a comprehensive base for examining this issue.

VARIABLES RELEVANT TO UNDERSTANDING THE ARTS EXPERIENCE

A frequent question in art and music education is whether people of various ages, sex, training, or personality classify objects or sounds in a similar manner. Research usually requires subjects to group a collection of stimuli—sounds, rhythms, geometric shapes or subject matter types. The researcher will keep one or more variables constant and manipulate or vary another to determine the influence of a particular dimension. Studies have shown a developmental sequence for particular solutions, but while the literature is clearer for subjects classifying simple stimuli (i.e., geometric forms) there is less agreement when subjects are required to classify more ambiguous stimuli such as art objects. One aspect is clear, however: all

studies demonstrate that intervention, or training, greatly facilitates a subject's ability to classify the stimuli on a specified dimension. As in a related cognitive question, such as conservation, familiarity with the stimuli, the nature of the task to be performed, and the subject's formal education emerge as clear factors in successful classification or judgment tasks.

Another area that demonstrates high agreement is eye movement studies. Looking behavior is never random. When one's activities require the intake of visual information, the focus of attention changes from instant to instant in an organized fashion. While the world surrounds us for a complete 360 degrees, vision is sharp only within a region of two degrees. Thus, a researcher may study where a responder directs this beam of vision and why it is of great importance. It is commonly agreed that contours, brightness and contrast of value consistently serve as sources of fixation. Naturally, this question has educational implications. Regarding the fixation of the eye on potential sources of information, just as chess masters are able to quickly isolate the main tension points in a game, sophisticated art viewers are able to immediately perceive the most informative and compositionally important effects in works of art. A basic rule of attention theory is that perceptual activities that provide an optimum level of complexity or mental processing tend to be favored over less demanding activities. This relationship holds true for the looking behavior of both adults and children.

Although research in arts education is carried out in many settings by a variety of research strategies which differ greatly in degree of control, precision of measurement and realism of context, most researchers make a strong effort to control the variables being studied in order to study the effects and to allow replication to take place. Let me provide examples of how this may be applied to arts education research. In Runkle and McGrath's insightful book on research methods, the authors use a pie graph to compare major research strategies used in behavioral research (Table 1). Essentially, there are eight strategies: formal theory, computer simulations, sample surveys, field studies, judgment tasks, field experiments, laboratory experiments and experimental simulations. These eight strategies are further compared on the continua of degree of obtrusiveness and particular versus universal behavior systems. Finally, these strategies are compared on three additional dimensions: maximum degree of generality over subjects, maximum concern with precision of measurement and maximum concern with generality of setting or context.

For example, if one is concerned with generalizing the results of a study over subjects and maximizing this generality, then one is more or less in the realm of sample surveys and formal theory. If one is concerned with

TABLE 1: Research Strategies

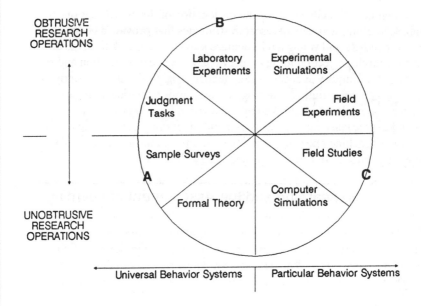

OBTRUSIVE
RESEARCH
OPERATIONS

UNOBTRUSIVE
RESEARCH
OPERATIONS

B
Laboratory Experiments
Experimental Simulations
Judgment Tasks
Field Experiments
Sample Surveys
Field Studies
A
Formal Theory
Computer Simulations
C

Universal Behavior Systems | Particular Behavior Systems

A. Point of maximum concern with generality over subjects
B. Point of maximum concern with precision of measurement
C. Point of maximum concern with system character of setting

precision of measurement and maximizing this concern, then one should use laboratory experiments or judgment tasks. If one is concerned with generalizing over settings, then field studies and field experiments should be considered. It is important to note that no single study can maximize all of these dimensions simultaneously. Thus, the researcher faces something of a dilemma in that any kind of research will have an inherent deficiency. At the same time, none of these strategies is lacking important advantages. There are no grand strategies for conducting research in the arts. However, since each strategy has its own kind of usefulness in gathering information about behavior, conditions or events, it makes good sense to consider a programmatic approach to research.

THE WORK OF THE NATIONAL ARTS EDUCATION RESEARCH CENTER

To that end, the University of Illinois location of the NAERC is organized to utilize a variety of research strategies that provide a perspective on how children and young adults acquire knowledge and skills in the arts. Each research project builds upon previous work in arts education and related fields of inquiry in order to gain deeper insights about the underlying factors which contribute to teaching, learning and evaluation in the arts. On balance, the projects undertaken by our division focus on two broadly defined issues: learning and the assessment of learning in the arts, and the process of teaching and the evaluation of arts programs in elementary and secondary schools. In brief, the projects are as follows.

Learning and the Assessment of Learning

Achievement testing in the visual arts. Considering the resurgence of interest in testing in the schools, teacher certification, statewide goals for art instruction and the like, the Center will examine issues in achievement testing and develop tests which assess student knowledge about the language and techniques of art, the structure of art, the content of history and aesthetics.

Cultural literacy and contextual understanding in arts education. Knowing what is involved in understanding art is central to the formulation of a viable theory of learning in arts education. This project will focus on the concept of cultural literacy for education in the visual, performing and literary arts at the secondary level.

The influence of cultural conditions on learning in art. The influence of culture upon the study of learning in the visual arts has received little attention. This study will examine the cultural and socio-economic variables that affect students' readiness for art experiences and the influence of select curriculum models and instructional strategies in the visual arts.

Development of computer-assisted testing in music. Testing in music has progressed from paper and pencil items to aural stimuli, but with the development of interactive software for computers, researchers can investigate variables such as the length and familiarity of selected musical examples, opportunities for more than one hearing and students' nonverbal responses to music. This project will conduct a series of studies focusing on a student's ability to perform musical tasks given and evaluated by a computer.

Motivation in music. The purpose of this investigation is to obtain insights regarding the development of attitudes and motivational patterns in response to musical instruction. The focus will be on the desirability of fostering mastery or intrinsic interest rather than on competitive orientation.

Teaching and Evaluation

Status of the arts in the schools. The purpose of this project is to provide a national perspective about art, dance, music and theater in public and private elementary, middle and secondary schools. While essentially four studies with multiple variables, this information will supplement the recent work of the National Endowment for the Arts, the U.S. Office of Education, the National Assessment for Educational Progress and several other regional surveys involving one or more of the arts. The results will provide additional information about the content of arts instruction, instructional practices, teacher and administrator attitudes about the arts, financial resources allocated to the arts and related demographic data. This study will be of particular value to researchers, policy makers, administrators and governmental agencies as they attempt to assess the condition of the arts in American education.

The role of music in general education. The importance of general education is well recognized, and traditionally the arts have been a critical part of that process. However, there has been a lack of congruence between the principles and practices of general education. This study will focus on the philosophical underpinnings of a rationale for music education in general education and follow with a series of rationale statements for the other arts.

Curriculum development in theater. This project will study the effect of long-term goals of theater in elementary, middle and secondary schools by conducting an in-depth case study of an integrated and sequential theater curriculum. Particular attention will be given to how theater teachers identify long-term goals for theater education, the use of instruction to develop performance, production, critical and historical content and how theater reflects various components of culture.

Curriculum development in dance. The thrust of this project will be to provide guidelines for curriculum development, teacher preparation and specialized programs for gifted students, and to develop a series of instructional resources that reorganize and integrate the content of dance. In addition, there will be a series of case studies of exemplary dance programs in secondary schools.

Studies of arts programs. Using a case study approach, this project will seek to document the present efforts of teachers, administrators and communities to provide opportunities for arts education. Rather than identifying exemplary practices, the goal of this study is to document day-to-day practices and problem solving efforts of schools with arts programming. Certain issues such as teachers' conceptual structure of arts activities and sources of funding will be examined. In addition, a series of correspondents from each state will be organized to provide supplementary information about the condition of arts education in their communities.

The Arts Education Research Center at New York University and the University of Illinois is funded on a yearly basis for a three-year period. Each of the major components of arts education research – that is, higher education, elementary and secondary education, governmental agencies and foundations – must develop a climate and an agenda that encourages careful and systematic research in arts education. Knowledge cannot be generated about teaching, learning and evaluation in the arts on a random basis, or only when funds are available. There must be an infrastructure of researchers, sources for dissemination and means for implementing the results of such work. Research and the dialogue about such work must be continuous. Thus, universities must demand that faculty advance knowledge in the arts; professional associations, academics and practitioners must insist upon the dissemination of knowledge about the critical issues of arts education; governmental agencies must take a long view about support for arts education research; and private foundations must supplement all of these efforts on a selective basis. In short, each of us, as representatives of one or more of these institutions, must actively support work that advances our understanding, teaching, learning and evaluation of arts programs.

THE NEED FOR POLICY STUDIES IN ARTS EDUCATION

by Samuel Hope

A dispassionate observer of American arts education would find an enterprise brimming with activities. These activities include lessons in classrooms and studios, school- and community-based performances and exhibitions, professional association activity, advocacy, education-oriented artist residencies and, of course, conference after conference after conference. America's transportation and hospitality industries surely receive disproportionate support from the arts education community. Indeed, if activity and discussions could produce results by their numbers alone, arts education should be among the healthiest enterprises in the nation.

This audience is not filled with dispassionate observers, and each of us views the field of arts education from a different perspective. Few are happy with the present state of affairs. We wouldn't describe arts education as a healthy enterprise, at least in an overall national sense. We probably all agree that there are linkages between problems in arts education and problems in the arts. We probably also agree that the problems we perceive in the arts and in arts education are large, multi-faceted and difficult to solve. Our agreement may begin to fall apart, however, when we begin to consider the availability and suitability of various means to address the questions that concern us. Further, it is quite probable that while we all recognize the same basic elements in the mix of concerns that create our problems, we do not agree on the relative importance of these elements either in creating our problems or in finding solutions to them. This condition results in the widely recognized lack of "unity" on arts education issues.

No one knowledgeable about American arts education could think that

Samuel Hope is executive director of the National Office for Arts Accreditation in Higher Education and executive editor of Design for Arts in Education.

any single reorientation might produce more solutions and unity for the field, for it is clear that the major camps in arts education do not trust or respect each other. Although a public intra-arts discussion continues on arts education, the results are agreement on a pitifully small series of platitudes. Attempts to move beyond such platitudes to serious action on behalf of students still runs into the kinds of problems that can only come from broad divergence on basic values.

I believe that the nation's overall arts education effort is far more productive than the national discussion which continues about it. While we are not satisfied with the number of students being reached with quality programs, there is no question that superior teaching and learning are taking place throughout the United States. Most often these successes are attributable to the knowledge, skills and dedication of individual teachers and administrators in specific locales. Even in the best of circumstances, however, there is always the underlying fear that the contextual value system will one day turn against any extant arts education program in pursuit of short-sighted educational or financial improvements. This constant fear of loss is not unique to arts education; it pervades every nook and cranny of our nation's arts enterprise. It is the major force creating factionalization and destructive competition among elements of the arts community. This force is likely to be with us for a long time to come, unless effective policy-oriented work begins to improve general understanding of the arts infrastructure.

During the last few minutes I implied positives about the condition of unity and negatives about its absence with respect to arts education. I have also suggested that the level of national discussion about arts education does not reach the quality of the arts education product itself. I would like to bring these two ideas together and use them as a basis for suggesting why there is a need for increased attention to policy studies in American arts education.

The issue of unity is particularly interesting. Unity has been the rallying cry of the American arts advocacy movement for nearly thirty years. A fundamental principle of arts advocacy remains that unity is essential for effectiveness. Some years ago it occurred to me that this concept might not be entirely correct. I noticed that the issues given the most importance in politics, the media, and in general discussion among the citizenry were precisely those issues that generated the most debate. The major issues of the day, from relationships with the Soviet Union, to welfare, to the quality of education, are all the subject of constant and often acrimonious exchange. For example, the intellectual fisticuffs waged over the nomination

of Robert Bork to the Supreme Court make disagreements about arts education look very tame indeed.

My conclusion is that the mere presence of disagreement does not diminish interest in a policy issue. Under the right conditions, it seems that the more intense the debate, the higher the level of attention. Since there is no lack of disagreement in the arts community and beyond about every issue related to K-12 arts education, what makes our field different, what are the conditions that cause us to be ignored? I believe one answer, and certainly not the only one, has to do with the fact that the arts education community, and in fact the arts community as a whole, has no policy oriented efforts that can begin to match those that are operating in more publicly controversial fields.

In fact, arts policy is focused narrowly on support, and usually even more narrowly on funding, and this even more narrowly on leveraging money from legislatures at various governmental levels. While such activities are worthwhile, they hardly merit use of the word *policy* in the same sense that one thinks of foreign policy. In foreign policy, attention is given not only to support for means but also for the meaning of means, the ramifications of means, and sometimes, even for ends. If the arts policy model were extrapolated onto foreign policy, all attention would be given to the budgets of American embassies and the numbers of attendees at embassy receptions; the entire foreign policy effort based in universities, think-tanks, and journals would disappear; the philosophical discussion about means would die. Serious damage to our capabilities for making and correcting our foreign policy would result, not because of a lack of unity but because of the absence of a quality debate.

Arts education is in a little better position, but not much. By being a part of the nation's education enterprise, arts education research, scholarship and policy development do not present the same manic focus on support issues. However, the arts education community cannot boast a full-blown policy effort that comes close to those addressing other major foreign and domestic policy concerns. Arts education research and scholarship are primarily oriented to scientific experimentalism, the search for method and analysis of the past. Policy-oriented efforts are most often focused on maintaining intellectual and political pressure to keep the idea of arts education alive. The tactical fight for time both in the school day and in teacher preparation is a voracious consumer of energy. While these endeavors are essential, they produce neither holistic views of the composite situation, nor broad-based strategies for moving forward. Such views and strategies and the debates surrounding their development and deployment are the essence

of policy work. The result of such work is an improved basis for two things: common understanding of the issues, and decision making at all levels. Failure to have state-of-the-art policy efforts in the arts and in arts education hurts the cause of each separately and the common cause of high civilization they both share.

I want to draw a distinction here between unity and working together effectively. It is common knowledge that members of legislatures often change alliances on the basis of issues rather than personalities, organizations or even party. Policy analysis is central to this continuous series of conversions. Without some holistic sense of the large issues and the strategic ramifications of proposed solutions, it is difficult to work from an informed perspective, to know how one's own interests relate to those of others. Policy-oriented approaches enable the concept of working together to override the concept of unity and, as such, represent a more pragmatic approach to solving problems.

Many decisions on arts education are made in local political arenas. However, the climate for political decision making covers territory that is as wide as American society. Our mailboxes are full of passionate appeals to join one cause or another. Our newspapers are full of ads, reportage and editorials; the electronic media ring with punditry. All of this produces the climate in which public opinion develops. Much of the content is derived from policy work that influences and sometimes directs those who manage letter-writing campaigns, edit newspapers and determine the slant of television news.

It is the presence of such policy activity based in ideas that gives meaning, direction and force to the decision-making process. It is the presence of policy studies that ties workaday activities to grand agendas to accomplish grand designs. Policy work articulates these agendas and designs, this articulation produces debate, and debate reshapes the agenda, the designs, and the interrelationships between the two. As long as the arts and arts education communities express their visions primarily in terms of numbers rather than in terms of ideas, they are likely to be disadvantaged in the various decision-making processes applied to their respective and collective futures. Great ideas call forth numbers to support them. Our experience in the arts and arts education over the last twenty-five years proves that the reverse is not the case.

Before making some specific recommendations about what policy studies in arts education might involve, I want to draw a further distinction between advocacy and policy. Policy work is centered in an intellectual search for means, albeit usually in terms of a specific value system applied

to particular ends. At best, advocacy is advertising; at worst, propaganda. In any case, advocacy is concerned with promotion of nostrums, panaceas, personalities and organizations. An advocacy effort cannot be characterized as a policy effort simply because it makes recommendations for decision makers. After all, what we are talking about here is not policy defined as a group of decisions or policy as the promotion of secular religions, but rather policy conceived as a process for gaining a holistic grasp of a field, this as a basis for wise and fruitful debate in the course of decision making. We are talking about a process that helps people to think rather than a technique that inveigles them to join a cause.

All this leads us to the issue of values. It will not take much to make policy efforts in arts education more sophisticated than they are now. However, art has several attributes that make policy work difficult when the worlds of art and education are combined. First, works of art can be enjoyed and appreciated without capabilities in the art forms themselves. It is hard to enjoy the beauty of a sophisticated mathematical proof without knowledge of advanced mathematics. It is difficult to appreciate the intricacies of a complex appellate court decision without some background in legal studies. However, it is perfectly possible, and indeed usual, for people to enjoy a Mozart symphony or a Rembrandt painting without knowing the first thing about music or art. The same is true in the other arts disciplines. In most cases, the more successful a work of art, the more the complexities of its construction recede into the background. This is hardly the case with most other disciplines. This attribute of art makes it difficult to make a convincing public case for general literacy in one or more of the arts.

As if the receding complexities characteristic were not problem enough, another attribute combines with it to raise our difficulties exponentially. This attribute involves art's ability to touch so many other aspects of human existence so deeply that it is easy to confuse study of the things that art touches with the study of art itself. The world of art is deep and rich in psychological, sociological, historical, political and other connections. This leads many to confuse psychological, sociological, historical and political studies centered on music, for example, with the study of music as a discipline. The fact that it is possible to "enjoy" music without knowing music as a discipline combined with the deep influence music has on other aspects of civilization has deflected many from the goal of basic musical literacy for American students as a basis for future personal growth. This phenomenon is particularly observable among those who come to high art music by virtue of their social and economic heritage rather than through serious study of music itself. The same conditions just ascribed to music are true of the other arts as well, and in the aggregate are a root cause of the values split

between arts advocates and arts educators.

These conditions have portentous ramifications for the future of policy studies in the arts and arts education. Just as it was possible in the 1960s to believe that advertising and advocacy technique would build conditions for art similar to those in the great periods of past cultural productivity, it is now possible to be equally as misguided by thinking that poll-based sociological studies grafted onto more sophisticated econometric projections will finally produce the cultural result that has been expected since 1965. Unless the underlying values base changes, such efforts will produce new, equally counterproductive, albeit more sophisticated, levels of superficiality. Without a values change, the game is hardly worth the energy.

What kind of values change is needed? It seems to me that successful policy efforts on the arts and arts education necessarily involve attempts to understand and project a more natural focus on art itself. Art advances because of talent, application, and visionary work. There are two kinds of vision applicable here. One is vision which produces a result that has never been conceived before. There is also the kind of vision which sustains the important values and discoveries of the past, this as a basis for the evolution of artistic development. The teacher who spends a career providing students with the knowledges and skills for access to their developing artistic heritage exemplifies this latter kind of vision, as does the member of a dance company or theatre troupe. Policy studies must be centered on sustaining such visions and their interrelationships in both fiscal and spiritual terms. As the past twenty-five years have shown, it is possible to reach the condition of form without spirit that the ancient Greeks called *porne,* the root of our word pornography. So much of the American arts scene is not about art. Art is just the label, a cover for all sorts of self-aggrandizing games. Unfortunately, the same is true of arts education. Establishing a new conceptual focus on art, therefore, becomes critical if we are to avoid approaching the total state of form without spirit, at least in terms of our general culture.

How can we establish a policy effort that will help us move forward? In a recent article for *Design for Arts in Education* magazine, I have spoken extensively about the search for common ground.[1] This search is under way in arts education because most of the groups involved realize that none can achieve hegemony. In my judgment, it is essential to connect our basic activities in arts education to a value system that is tied both to the nature of art and to the vision we have for the future of American high culture. It is instructive to ask oneself what one hopes the cultural life of the United States will be like in the year 2000. If one seeks a vibrant outpouring of artistic

productivity from American minds and hands supported by an enthusiastic and knowledgeable audience, one must ask in personal and larger terms what is needed to achieve such a goal. I suggest that without such a cultural vision based in aspirations for high civilization, so-called policy studies on the arts and arts education are apt to degenerate further into the plebiscite mentality that is so antithetical to great works of the spirit.

If one aspect of our policy thrust is the search for a workable scheme of values, the other aspect deals with work on the relationship between context and means. It involves the balance of social forces and the evolution of ideas that either advance or block achievement of our aspirations. Debates over such issues as the balance between experience-based and curriculum-based arts education become little more than economic squabbles among interest groups unless such balances are sought in relationship to a particular vision for the future cultural climate of the nation. I ask each of you to think of all of the pieces of the arts education debate that relate to curriculum and teaching, all the pieces that relate to research, all the pieces that relate to governance, and all the pieces that relate to the promotion of arts education in various decision-making contexts.

Having assembled this rather daunting set of difficult and controversial issues in your mind, now consider how these issues will evolve in a future that will be characterized by incredible technological advances, difficult demographic changes and uncertain economic contexts. Some of the results are expected to be increasing fragmentation by economic level and educational achievement, a political climate increasingly dominated by an aging population, and a home-centered lifestyle. Studies are already under way in other fields regarding each of these projections. However, I am not aware of any policy-oriented studies on arts education that are looking seriously at the ramifications of these developments for the future of our field. Please understand here that I am making a distinction between meetings and conferences where attendees share experiences and impressions with a kind of endeavor characterized by intellectual work of a high order that involves skills in analysis and philosophical projection. The problems are simply too complex for advocacy technique to create solutions.

For some years, I have felt that both the arts and arts education communities have too small a role in the cultural leadership of our nation. If I am correct, the inability of these fields to achieve significant cultural leadership is linked mightily with the resource problems that plague the field. By resources, I mean much more than simply money and the things that money can buy. In my judgment, we suffer from a lack of spiritual resources far more than we suffer from a lack of fiscal resources. During the past twenty-

five years too many in the arts community failed to recognize the difference between audience development and selling tickets.

If one can place some faith in the ability of human beings to reason together, it follows that policy analysis has much to contribute to raising the level of our discussion. It can do so by establishing criteria for judging the success of our efforts that have validity in artistic terms. I do not make this proposal to suggest that present intellectual work in arts education should be scrapped. However, I do suggest that without increased productivity in policy analysis, the tragic cycle of the arts education melodrama seems fated to remain unbroken. Our challenge is to create an improved sense of values and an improved context to support the integrity of our conceptual and operational aspirations. I need only point to the series of highly promoted arts education panaceas left dead or dying in the forum of ideas during the last twenty-five years. After all the hoopla is over and the major players have gotten their press coverage as do-gooders, the practice, the teaching and the learning of art must go on, often in more difficult contextual circumstances than before. Currently, the arts education community is working at a supreme disadvantage because without a significant policy capability its efforts to make improvements are most often tactical rather than strategic and imitative rather than indigenous. Strategic thinking and contextual analysis are rare. I hope that the arts education community can recognize this fact and that a few major postsecondary institutions will undertake a prompt remediation of this significant problem. If not, I fear the future of arts education will be characterized by the constant refrain "too little, too late." Let us hope that our future is not characterized by the message I saw on a bumper sticker the other day. It read: "Honk if you're illiterate."

[1] Samuel Hope, "Searching for Common Ground," *Design for Arts in Education* 89, no. 5 (May/June 1988): 13-22.

POSTSCRIPT: Toward Civilization Through Arts Education

by Kevin V. Mulcahy

The last few years have seen an explosion in publications arguing for the primacy of "cultural literacy" in American education. The title of E.D. Hirsch's book[1] has become a popular catchphrase for what is deficient in the shared knowledge of most students. Diane Ravitch and Chester Finn[2] have detailed what our seventeen year olds do not know about history and literature. Lynne Cheney[3] and William Bennett,[4] the two chairs of the National Endowment for the Humanities during the Reagan administration, have decried the sorry state of humanistic education in the nation's public schools and universities. In one of the publishing phenomena of the decade, Allan Bloom's *The Closing of the American Mind*[5] indicts the value system of higher education since the 1960s. This cannot be the occasion for a discussion of the methodological and substantive arguments raised in these works — and one has been offered by this writer elsewhere[6] — except to note two commonalities. The first is that there is an appalling ignorance among virtually all students about the content of what was traditionally assumed to be the cultural heritage of an educated person; second, it is the obligation of the schools at all levels to restore classical educational values to a central place in the curriculum.

With *Toward Civilization: A Report on Arts Education,*[7] the National Endowment for the Arts (NEA) has made a surprisingly belated contribution to the great educational debate of the 1980s. In fact, the arts education report insists repeatedly that the NEA is not an educational agency. On the other hand, there are frequent assertions that "the National Endowment for the Arts is to arts education what the National Endowment for the Humanities and the National Science Foundation are to humanities and science education" (p. 32). Yet, the NEA allocates less time and money, as a proportion of its overall activities, to arts education than its counterpart agencies. "The Arts Endowment spends 3.3 percent of its current budget for its Arts in Education Program, compared to 12.8 percent of the

Humanities Endowment budget for humanities education and just over 5 percent of the Science Foundation's much larger budget for science education" (pp. 32-33). The NEA has historically addressed the needs of professional artists and arts institutions, with arts education basically as a poor relation. However, given the importance of early childhood exposure to the arts and adult appreciation, arts education may be the missing link in realizing the goals of broad access and wide support associated with cultural democracy.

Without proposing to write another report, two major realizations have come to this reviewer in reading *Toward Civilization;* that is, we are in danger of producing a generation of cultural illiterates, and the schools offer the best hope of remedying what could be a national tragedy. Most important, K-12 arts education offers the best means for achieving "cultural equity." This goal, which David B. Pankratz has defined as the right of every citizen to participate as a producer or consumer at some minimum level of cultural activity, requires the use of public arts funds to redress past injustices against cultural minorities.[8] Arts education is no more the exclusive concern of a cultural elite than it is a pedagogical frill. As Arthur Schlesinger argued in the First Annual Nancy Hanks Lecture on Arts and Public Policy,

> Is not the real elitism to suggest that low-income people have no interest in the arts and can derive no benefits from public support of the higher arts? Surely the poor as well as the better-off have appetites to be awakened, yearnings to be clarified, lives to be illuminated.[9]

A heightened emphasis on arts education could provide cultural opportunities on a basis that is less related to social-class background than is usual with museums and performing arts centers. Schools, with their local roots, may also be best situated to relate to the minority and community cultures that are traditionally underrepresented in the arts world. Accordingly, the NEA should commit itself to a policy of cultural democracy that would seek to broaden public appreciation of, and participation in, the arts. Specifically, the NEA should reorganize its administrative structure and funding priorities to recognize the centrality of arts education.

Accomplishing this goal would require two changes in the Arts Endowment's operations. The first would be a shift from administration by art discipline to administration by cultural objective. Rather than apportioning the arts budget among the various institutional claimants, the NEA could make grants by the goals to be realized: maintenance of arts institutions, arts development and arts education. This would allow the arts budget to be

driven by overall policy objectives rather than by a calculus of institutional needs or political support. The second change is related: support for arts education should be dramatically increased — at least equaling the roughly 13 percent spent by the NEH on humanities education.

While these suggestions may appear radical in scope (as well as politically naive), they are actually quite pragmatic. Without a culturally-aware public, there can be no long-term support for a public arts policy; and, without a broad-based arts policy, there can be little justification for public support. Arts education is not a panacea for what has been well documented as the cultural underdevelopment of the American public. However, it is a step toward a recognition of what the arts have to offer for our personal development; and, of course, it is a step toward civilization.

NOTES

1. E.D. Hirsch, *Cultural Literacy: What Every American Needs to Know* (Boston: Houghton Mifflin, 1987).

2. Diane Ravitch and Chester E. Finn, Jr., *What Do Our 17-Year-Olds Know? A Report on the First National Assessment of History and Literature* (New York: Harper and Row, 1987).

3. Lynne V. Cheney, *American Memory: A Report on the Humanities in the Nation's Public Schools* (Washington, D.C.: National Endowment for the Humanities, 1987).

4. William Bennett, *To Reclaim a Legacy* (Washington, D.C.: National Endowment for the Humanities, 1985).

5. Allan Bloom, *The Closing of the American Mind: How Higher Education Has Failed Democracy and Impoverished the Souls of Today's Students* (New York: Simon and Schuster, 1987).

6. Kevin V. Mulcahy, "Cultural Illiteracy and the American Cultural Heritage," *Journal of Politics* 51 (Winter 1989).

7. *Toward Civilization: A Report on Arts Education* (Washington, D.C.: National Endowment for the Arts, 1988).

8. David B. Pankratz, "Toward an Integrated Study of Cultural and Educational Policy," *Design for Arts in Education* (November/December, 1987): 17.

9. Arthur Schlesinger, Jr., *America, the Arts and the Future,* First Annual Nancy Hanks Lecture on Arts and Public Policy, April 13, 1988, Washington, D.C.

APPENDICES

APPENDIX A: THE INTERLOCHEN PROPOSAL

The one hundred and fifty delegates to the Interlochen symposium, comprising representatives of the fields of education, arts, and arts education, believe that:

WHEREAS education must focus on the child, how the child learns and interacts in the schoool environment; and

WHEREAS each child deserves the opportunity to develop all dimensions of his or her being; and

WHEREAS each child should have the opportunity to explore a diversity of subjects and fields:

THEREFORE, to achieve these goals, arts educators must collaborate with a broad range of colleagues in the arts, humanities, and sciences to develop a school agenda that improves the total life of the school and allows each child to reach his or her full potential. We must participate in an overall effort to improve education in the schools.

WHEREAS all members of society should be knowledgeable and interactive in all art forms; and

WHEREAS a variety of levels of involvement and achievement in the arts are appropriate:

THEREFORE, American schools, K-12, should provide arts education for all students every day. Instruction in the arts should encompass visual arts, music, dance, theater, and creative writing. It should be accorded resources of time, money, and personnel equivalent to other basic subject areas, and the same level of expertise. Every school should have an in-school sequential arts program that serves all the children.

To accomplish these fundamental goals for arts education, we endorse the following:

1. We recommend that all participants in this conference will now move to broaden the base of endorsement for the "Philadelphia Resolution" and the "Concepts for Strengthening Arts Education in the Schools," both in their own organizations and beyond. Questions raised should be returned to a core group for consideration and potential revisions of the statements. Expansion of the dialogue is a key objective

2. We recommend that the need for a national organization to serve as umbrella spokesman for arts education be addressed. Among the purposes to be served by such a body would be the following:
– formulation of a five-year plan for expansion of arts education
– conducting national symposia on arts education for nonarts education constituents
– providing leadership in bringing together arts education leaders at national, state, and local levels

3. We recommend recognition of the following groups or stakeholders in arts education, and we recommend efforts to include these groups in the coalition working for arts education:
– professional arts education associations
– museums and cultural institutions
– arts providers and arts producing organizations
– elected government officials
– appointed policy-workers
– artist unions
– service organizations of educational administrators
– arts education researchers
– arts related industries
– print and broadcast media
– arts advocacy groups
– government arts agencies
– colleagues in the humanities
– colleagues in the sciences
– constituencies becoming more influential as demographics change, including multicultural populations and older Americans
– special populations
– parent and student populations

4. We recommend the development of informational resources, including:
- – a data base concerning activities and programs in arts education
- – a historical analysis of collaborative efforts in the arts
- – an analysis of models of individual and group collaboration an arts education
- – a glossary which defines the terminology of arts education
- – a compendium of national standards and guidelines for individual arts

5. We recommend:
- – the inclusion of production/creation and performance, analysis and evaluation, and historical and cultural understandings in instructional programs in the arts
- – that the content of instructional programs in the arts be developed by the specialist teachers in consultation with artists, administrators, and other knowledgeable persons in the community
- – that the content of instructional programs in the arts reflect multicultural concerns and values
- – that strategies be developed for evaluation that address the nature of the individual art forms and their respective instructional components

6. We recommend the following conditions in schools and colleges:
- – that every secondary school have at least seven periods a day, a length sufficient to permit study of the arts
- – that approximately 15 percent of the instructional program of every student at all levels, K-12, be devoted to the arts
- – that every high school require at least two units of study in music, art, theater, dance and creative writing for graduation
- – that every college or university require at least one course in music, theater, art, or dance for admission, and one course in these disciplines for graduation
- – that every prospective classroom teacher have at least 12 semester hours of credit in methods and materials for teaching the arts
- – that every school district employ qualified supervisors in the visual and performing arts

APPENDIX B: PHILADELPHIA RESOLUTION

WHEREAS, American Society is deeply concerned with the condition of elementary and secondary education; and

WHEREAS, the arts are basic to education and have great value in and of themselves and for the knowledge, skills and values they impart; and

WHEREAS, the arts are a widely neglected curriculum and educational resource in American schools; and

WHEREAS, every American child should have equal educational opportunity to study the arts as representations of the highest intellectual achievements of humankind;

THEREFORE, the undersigned individuals, representing a broad cross-section of national arts organizations, agree:

THAT EVERY elementary and secondary school should offer a balanced, sequential, and high quality program of instruction in arts disciplines taught by qualified teachers and strengthened by artists and arts organizations as an essential component of the curriculum;

THAT WE PROMOTE public understanding of the connections between the study of the arts disciplines, the creation of art, and development of a vibrant, productive American civilization;

THAT WE URGE inclusion of support for rigorous, comprehensive arts education in the arts development efforts of each community;

THAT WE PURSUE development of local state and national policies that result in more effective support for arts education and the professional teachers and artists who provide it.

APPENDIX C: CONCEPTS FOR STRENGTHENING ARTS EDUCATION IN SCHOOLS

To increase the level of artistic literacy in the nation as a whole, the arts must be taught with the same rigor, passion and commitment with which they are created and presented to the public. The primary responsibility to educate students rests with teachers, school administrators, and ultimately, local school boards who represent the public. But we all have a stake in this undertaking: artists, arts organizations, professional and community schools of art, arts teachers and administrators, those who teach the next generation of artists and teachers, and all those who believe the arts should be an integral part of people's lives.

We will work to establish the arts as an equal partner in the educational enterprise. The arts and arts education communities define common goals and discover the role each will play to further a vision of the future that includes the arts at the center of American values and practice.

Together, we advance these philosophical and operational concepts:

1. The arts should be taught as disciplines to all students. This includes student involvement in creating, studying, and experiencing the arts.

2. Regular instruction in the various arts must be a basic part of the curriculum in all elementary and secondary schools; such instruction must be integrated with the highest quality arts experiences both in schools and in theatres, concert halls, and museums; such experiences must be integrated with instruction as part of comprehensive curricula.

3. Arts curricula should be for the development of skills in and knowledge of the arts. In addition, learning about and experiencing the arts can develop critical and creative thinking and perceptual abilities that extend to all areas of life. These benefits are best imparted through instruction in the basic skills in and knowledge of the arts.

4. The arts relate naturally to much of the content of the total educational curricula. For this reason, all teachers should be encouraged to incorporate arts skills and knowledge into their instruction in order to enliven, broaden, and enrich all learning.

5. The curricula of teacher education programs in general should have a stronger arts component as part of the pedagogical preparation of all teachers.

6. Pre-service and in-service training of both teachers and artists should be augmented to include significantly greater experience of one another's working methods. Arts education benefits when arts teachers have high

levels of artistic skill and knowledge of the arts, and when artists develop teaching abilities and knowledge of child development.

7. Resources are often available through individuals and arts organizations and in elementary, secondary, and postsecondary education to form the foundation for quality arts education programs in each local community. These resources must be identified, integrated, utilized and expanded.

8. The local focus for decision-making about arts services and arts education, including local control over curricula, must be respected. Within this framework, ways must be found at the local level to meet or exceed the goals and standards established by professional arts education associations and accreditation authorities. This should include criteria for school programs, certification of personnel, the participation of arts organizations, and for artist and teacher preparation programs.

9. Arts education programs, which are designed to increase cultural literacy, will build audiences and strengthen community volunteer and funding support for cultural, visual and performing arts organizations and institutions. Therefore, these organizations should allocate significant resources and efforts in support of arts education.

10. We must establish for arts education a coordinated policy-making process that includes the arts and arts education communities. Over time, this will vastly increase our ability to affect the policies of others whose support is needed to make the arts and the study of the arts more central to the educational mission of communities throughout the country.

11. Basic research, model projects, and advocacy efforts are critical to establishing a consistent and compelling case for increasing the economic base of support for arts education in schools and in the community at large. While the primary responsibility for increasing budget allocations in support of education programs rests with local school boards and administrators, we all must recognize our share in this responsibility as members of the larger society. We must build a powerful community constituency at local, state and national levels among arts and arts education organizations to initiate a step-by-step process for change.

PARTICIPATING ORGANIZATIONS

Ad Hoc National Arts Education Working Group
Alliance for Arts Education
Alliance of Independent Colleges of Art
American Association of Museums
American Association of Theatre for Youth
American Council for the Arts
American Dance Guild
American Symphony Orchestra League
The College Music Society
Dance U.S.A.
High Fidelity/Musical America
International Council of Fine Arts Deans
Kennedy Center Education Program
Maryland Institute College of Fine Arts
Music Educators National Conference
National Art Education Association
National Assembly of Local Arts Agencies
National Assembly of State Arts Agencies
National Association of Jazz Educators
National Association of Schools of Art and Design
National Association of Schools of Dance
National Association of Schools of Music
National Association of Schools of Theatre
National Band Association
National Dance Association
National Guild of Community Schools of the Arts
National Music Council
Opera America
State Arts Advocacy League
Very Special Arts
Young Audiences

OTHER BOOKS IN THE
ARTS RESEARCH SEMINAR SERIES

ARTS EDUCATION BEYOND THE CLASSROOM
Edited by Judith H. Balfe and Joni Cherbo Heine

Addresses and defines a new field: arts education for adults outside of formal academic settings. This book offers a broad range of insights from arts educators who work in a variety of corporate, community and arts institutional settings.
ISBN: 0-915400-63-4; Price: $9.95

WHO'S TO PAY FOR THE ARTS?
The International Search for Models of Support
Edited by Milton C. Cummings and J. Mark Davidson Schuster

Harry Chartrand of The Canada Council, Cummings and Richard Katz of Johns Hopkins, Schuster of M.I.T. and John Meisel of Queen's University incisively dissect the policies, structures, and financing of government arts support in many Western nations.
ISBN: 0-915400-74-X; $9.95

THE COST OF CULTURE:
Patterns and Prospects of Private Arts Patronage
Edited by Margaret Wyszomirski and Pat Clubb

Private sector support is vital to the health of the arts. Yet the nature of that support is changing. Judith Balfe of C.U.N.Y., Clubb of the Texas Commission on the Arts, Mark Schuster of M.I.T. and Michael Useem of Boston University analyze changing trends in private giving and forecast potential consequences for the arts.
ISBN: 0-915400-76-6; Price: $9.95

CONGRESS AND THE ARTS:
A Precarious Alliance?
Edited by Margaret Jane Wyszomirski

This book paves the road for understanding the relationship between Congress and the arts. Three intensely provocative essays address the life of the arts within Congress and the manner in which people can affect the arts through political action committees, advocacy groups, etc.
ISBN: 0-915400-62-6; Price: $9.95

THE MODERN MUSE:
The Support and Condition of Artists
Edited by C. Richard Swaim

Richard Brown, John Robinson of the University of Maryland, C. Lynn Cowan of John Hopkins, Bruce Payne of Duke University, Thomas Bradshaw, Ruby Lerner, Sanford Hirsh of the Gottlieb Foundation and others tackle key issues and provide valuable insights with which to develop solutions. Find out what we know and don't know about our artists — who they are, how they survive, and what they need.
ISBN: 0-915400-75-8; Price: $9.95

Henry C. Rogers
Mrs. Paul Schorr III
Gerard Schwarz
Mrs. Alfred R. Shands III
Mrs. David E. Skinner
Kathy D. Southern
Elton B. Stephens
John Straus
Roselyne C. Swig
William Taylor
Allen M. Turner
Esther Wachtell
Vivian M. Warfield
Mrs. Gerald H. Westby
Arthur Whitelaw
Mrs. Pete Wilson
Masaru Yokouchi

Legal Counsel
Howard S. Kelberg

Special Counsel
Jack G. Duncan

MAJOR CONTRIBUTORS

GOLDEN BENEFACTORS
($75,000 and up)
American Telephone & Telegraph
Company
Gannett Foundation
Southwestern Bell

BENEFACTORS
($50,000 to $74,999)
Aetna Life and Casualty Company
The Ahmanson Foundation
National Endowment for the Arts

PACESETTERS
($25,000 to $49,999)
American Re-Insurance Company
Mr. and Mrs. Jack S. Blanton, Sr.
The Coca-Cola Company
Eleanor Naylor Dana Trust
Interlochen Arts Center
Johnson & Johnson
Philip Morris, Inc.
New Jersey State Council
 on the Arts
The Reed Foundation
The Ruth Lilly Foundation

Sears, Roebuck, & Co.
Elton B. Stephens
Mr. and Mrs. Richard L. Swig

SUSTAINERS
($15,000 to $24,999)
Bozell Inc.
Geraldine R. Dodge Foundation
Exxon Corporation
IBM Corporation
Mutual Benefit Life
Peat Marwick Main
Reverend & Mrs. Alfred R. Shands III
John Ben Snow Memorial Trust
Metropolitan Life Foundation
Rockefeller Foundation
The San Francisco Foundation
John Straus

SPONSORS
($10,000 to $14,999)
ARCO
Ashland Oil, Inc.
Equitable Life Assurance Society
Toni K. Goodale
The Irvine Company
Susan R. Kelly
New York Community Trust
N.W. Ayer, Inc.
Mrs. Charles Peebler
The Prudential Foundation
Murray Charles Pfister
Mr. and Mrs. Paul Schorr III
Starr Foundation

DONORS
($5,000 to $9,999)
The Allstate Foundation
American Stock Exchange, Inc.
Ameritech
BATUS, Inc.
The Arts, Education and
 Americans, Inc.
Bell Atlantic
Mary Duke Biddle Foundation
Boeing Company
Mr. & Mrs. Martin Brown
CIGNA Foundation
Chase Manhattan Bank
Dayton Hudson Foundation
Joseph Drown Foundation
Jeaneane B. Duncan

About the American Council for the Arts /95

Sunny Dupree, Esq.
Federated Investors, Inc.
The First Boston Corporation
Ford Motor Co. Fund
Gannett Outdoor
Goldman, Sachs & Company
Mr. & Mrs. John Hall
David H. Harris
Louis Harris
The Hartford Courant
Howard S. Kelberg
Ellen Liman
The Joe and Emily Lowe
 Foundation, Inc.
MBIA Inc.
Lewis Manilow
Merrill Lynch, Pierce, Fenner &
 Smith, Inc.
Mobil Foundation, Inc.
Morgan Guaranty Trust Company
J.P. Morgan Securities
Morgan Stanley & Co.
Morrison Knudson Corporation
New York Times Company
 Foundation
Pacific Telesis Group
RJR Nabisco
General Dillman A. Rash
David Rockefeller, Jr.
Henry C. Rogers
Mr. and Mrs. Leroy Rubin
Shell Companies Foundation
Schering Corporation
Allen M. Turner
Warner-Lambert Company
Whirlpool Foundation
Xerox Foundation

CONTRIBUTORS
($2,000-$4,999)

Abbott Laboratories
Alcoa Foundation
Allied Corporation
American Electric Power
 Company, Inc.
American Express Foundation
Mr. and Mrs. Curtis L. Blake
Gerald D. Blatherwick
Edward M. Block
Borg-Warner Co.

Mrs. Eveline Boulafendis
Donald L. Bren
Bristol-Myers Fund
C.W. Shaver
The Chevron Fund
Terri & Timothy Childs
Robert Cochran
Mr. & Mrs. Hill Colbert
Mr. & Mrs. Donald G. Conrad
Barbaralee Diamonstein-Spielvogel
Mr. & Mrs. Charles W. Duncan, Jr.
Mrs. George Dunklin
Eastman Kodak Company
Emerson Electric
Ethyl Corporation
GFI/KNOLL International
 Foundation
Donald R. Greene
Eldridge C. Hanes
Mr. & Mrs. Irving B. Harris
Ruth & Skitch Henderson
Henry Kates
John Kilpatrick
Knight Foundation
Kraft, Inc.
Mr. Robert Krissel
Frank W. Lynch
Mr. & Mrs. John B. McCoy
Marsh & McLennan Companies
Monsanto Company
Robert M. Montgomery, Jr.
Velma V. Morrison
New York Life Foundation
The Overbrook Foundation
Mr. & Mrs. Thomas Pariseleti
Procter & Gamble Fund
Raytheon
Mr. & Mrs. Richard S. Reynolds III
Judith & Ronald S. Rosen
Sara Lee Corporation
Frank A. Saunders
David E. Skinner
Union Pacific Foundation
Mrs. Gerald H. Westby
Westinghouse Electric Fund
Mrs. Thomas Williams, Jr.

PATRONS
($1,000-$1,999)

Morris J. Alhadeff
Mr. & Mrs. Arthur G. Altshcul

Mrs. Anthony Ames
AmSouth Bank N.A.
Archer Daniels Midland Co.
Anne Bartley
Mr. Wallace Barnes
Bell South
Mr. & Mrs. Evan Beros
Binney & Smith
T. Winfield Blackwell
Houston Blount
Bowne of Atlanta, Inc.
William A. Brady, M.D.
Alan Cameros
Gary T. Capen
Mr. & Mrs. George Carey
Chris Carson
Mrs. George P. Caulkins, Jr.
Mr. Campbell Cawood
Mrs. Jay Cherniack
Chesebrough-Pond's, Inc.
Chrysler Corp.
Citizens and Southern
 Corporation
David L. Coffin
Thomas B. Coleman
Mr. & Mrs. Marshall Cogan
Cooper Industries Foundation
Mrs. Howard Cowan
Cowles Charitable Trust
Cummins Engine Foundation
Mrs. Crittenden Currie
John G. Crosby
David L. Davies
Carol Deasy
Jennifer Flinton Diener
Eugene C. Dorsey
Ronald & Hope Eastman
EBSCO Industries, Inc.
Mrs. Hubert Everist
Mary & Kent Frates
Stephanie French
Frederick P. Furth
Mr. & Mrs. Edward Gaylord
Mr. and Mrs. Edward Gildea
Lee Gillespie
Dr. and Mrs. John M. Gibbons
Mr. & Mrs. Robert C. Graham, Jr.
Lois Lehrman Grass
Richard M. Greenberg
Mr. & Mrs. W. Grant Gregory

Bernice Grossman &
 Stephen Belth
R. Philip Hanes, Jr.
Mr. & Mrs. Joseph Helman
Mrs. Skitch Henderson
Edward I. Herbst
Admiral & Mrs. B.R. Inman
Mrs. Lyndon B. Johnson
Mr. & Mrs. Thomas Jolly
Alexander Julian
L. Paul Kassouf
Mrs. Albert S. Kerry
Shane Kilpatrick
Mrs. Roy A. Kite
Mrs. James Knapp
Henry Kohn
Mrs. C.L. Landen, Jr.
Mrs. Wilbur Layman
Fred Lazarus IV
Thomas B. Lemann
Robert Leys
Dr. & Mrs. James L. Lodge
Mrs. Robert Lorton
Mr. & Mrs. I.W. Marks
Mr. & Mrs. Peter Marzio
Mr. & Mrs. James W. McElvany
Florence D. McMillan
Tim McReynolds
Mrs. Michael A. Miles
Mr. & Mrs. Reese L. Milner II
Wendy & Alan Mintz
Mr. & Mrs. George Mitchell
Mr. & Mrs. Robert Mosbacher
Sondra G. Myers
Mr. and Mrs. William G. Pannill
Pantone, Inc.
Diane Parker
Mr. & Mrs. Scott Pastrick
Jane Bradley Petit
Mr. & Mrs. Harry Philips, Jr.
Philips Petroleum Foundation
Mrs. Arliss Pollock
Mr. & Mrs. John Powers
W. Ann Reynolds
William T. Reynolds
Mrs. Kay Riorden-Steuerwald
Mr. & Mrs. William A. Roever
Ronald S. Rosen
Mr. & Mrs. Eugene S. Rosenfeld
Rubbermaid, Inc.